Curious Tales of WORKINGTON

Curious Tales of WORKINGTON

Derek Woodruff

AMBERLEY

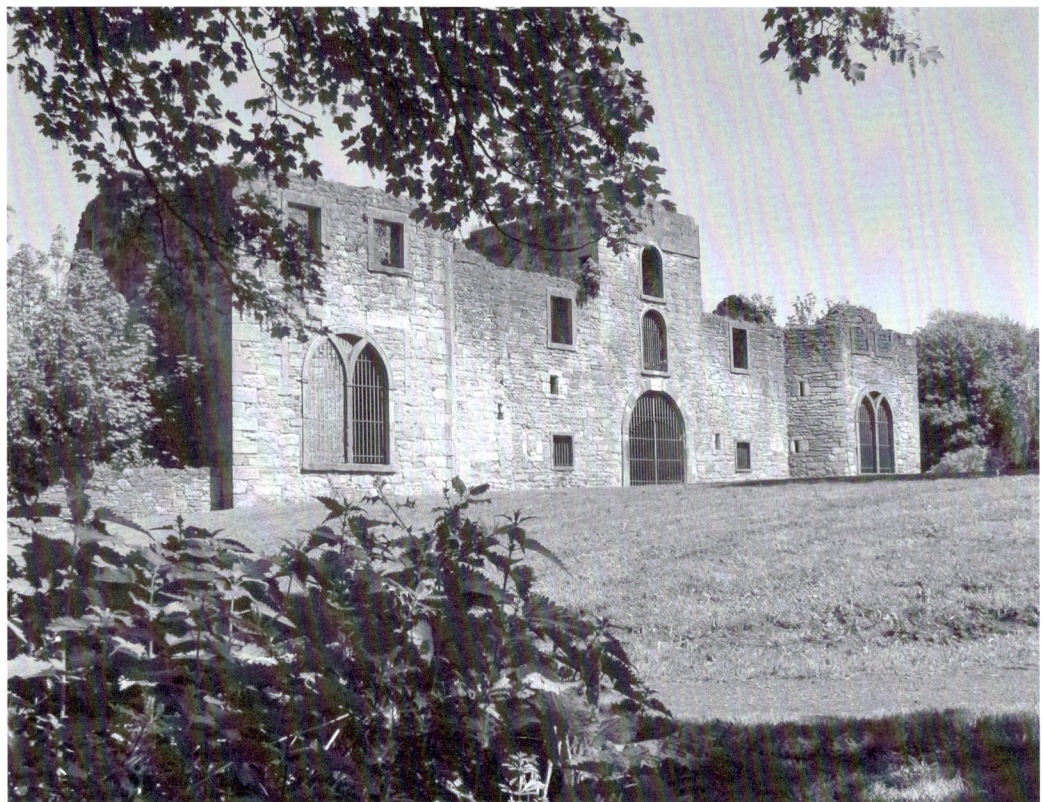

Workington Hall today.

First published 2009

Amberley Publishing Plc
Cirencester Road, Chalford,
Stroud, Gloucestershire, GL6 8PE

www.amberley-books.com

Copyright © Derek Woodruff, 2009

The right of Derek Woodruff to be identified as the
Author of this work has been asserted in accordance
with the Copyrights, Designs and Patents Act 1988.

ISBN 978 1 84868 856 8

All rights reserved. No part of this book may be
reprinted or reproduced or utilised in any form or by
any electronic, mechanical or other means, now known
or hereafter invented, including photocopying and
recording, or in any information storage or retrieval
system, without the permission in writing from the
Publishers.

British Library Cataloguing in Publication Data.
A catalogue record for this book is available from the
British Library.

Typeset in 10pt on 12pt Sabon.
Typesetting and Origination by FONTHILLDESIGN.
Printed in the UK.

Contents

		Introduction	9
Chapter	1	The Curious Affair of Mary Queen of Scots	11
Chapter	2	One That Did Not Get Away	17
Chapter	3	Travellers' Tales	19
Chapter	4	Inventors and Inventions	21
Chapter	5	Pubs and Drinkers	23
Chapter	6	The Uppies and Downies Game	27
Chapter	7	The Great Marathon of 1903	31
Chapter	8	An Involvement with Beecham's Pills?	35
Chapter	9	On Matters Medical	39
Chapter	10	Who Will Put Out My Fire?	43
Chapter	11	Some Curious Tales and the Inexplicable	47
Chapter	12	The Story of Friars Well	57
Chapter	13	Taxes and Taxation	59
Chapter	14	Oddities from the Upper Town	63
Chapter	15	The Marsh and Quay	67
Chapter	16	Around the Town	73
Chapter	17	'Don't Go Down the Mine, Daddy — There's Plenty of Coal in the Cellar.'	83
Chapter	18	Tales in the Toilets	89
		Acknowledgements and Sources	91
		Photographic Index	93

Camerton Church.

St Michael's Parish Church.

Helena Thompson Museum.

The quay side at Workington.

Curious Tales of Workington

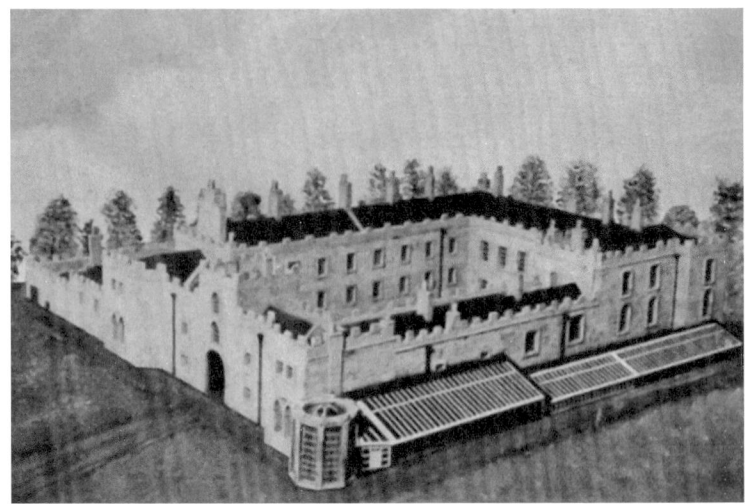

Workington Hall after 1790.

Workington Brewery.

Introduction

Once more a collection of the many facets of Workington's history. *Curious Tales of Workington* is a recollection of the events, facts and folklore that have helped to create the story of this town called Workington. Tales have been recalled from the Curwen histories, old newspapers and general recorded apocrypha, the authenticity of which lies in the past with the original narrators and recorders.

Given the fact that people can be diverse in their attitudes and psychology (there's nowt as queer as folk!) and given the individuality of this town, which goes back to before the Roman era, many odd events have occured in the story of Workington. This small volume is a collection of some of these curious happenings from the past few centuries. My special thanks go to all those people, friends and colleagues who have allowed me to pick their brains and memories. Let's be fair, they have picked mine as well!

Derek Woodruff, 2009

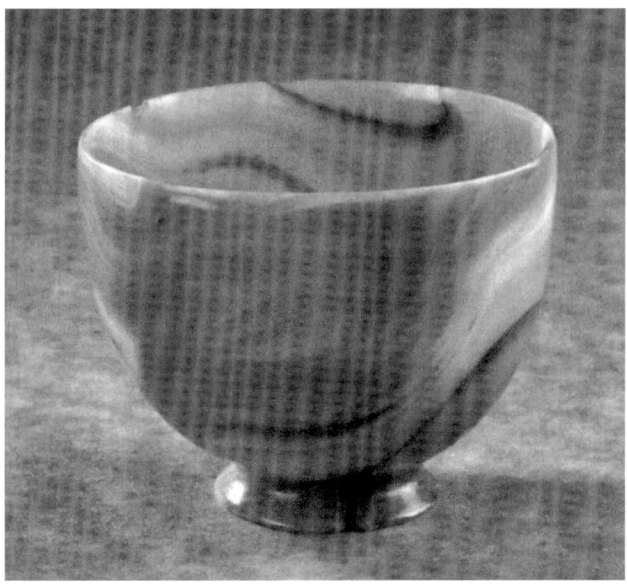

The Luck of Workington.

A recent trip to the Mary Queen of Scots memorial.

Chapter 1

The Curious Affair of Mary Queen of Scots

The enforced visit to Workington in the year of 1568 by the young Queen of Scotland has long been regarded as the high point of the town's history. However, the visit was accompanied by a number of oddities and curiosities that have, so far, not been fully explained.

Given that Elizabeth I was de facto illegitimate (a fact that the Protestant subjects of England hotly denied), as the widowed Queen of France and the Queen of Scotland, Mary Stuart was, as Pope Pius V decreed, also the Queen of England. The Pope, of course, went even further by declaring he would offer absolution to anyone who assassinated Elizabeth. There were many English Catholics who wanted a Catholic queen on the throne, and as history shows, there were attempts on Elizabeth's life and plots to put Mary Stuart on the throne of England.

Mary lost her second bid for the throne of Scotland at the ill-fated battle of Langside, and she was forced to fly for her life and seek the mercy of her cousin, Queen Elizabeth of England. She had written a letter to Lord Scrope, Warden of the West March at Carlisle, presumably making for the safety of that city; then, quite unexpectedly, she turned up at Workington Hall. You can see the situation the young queen was in: had she been captured by the Regents of Scotland, it would have been a deep dungeon or possibly worse (once the Regents had taken command of her infant son, the future James VI of Scotland and I of England, Mary Queen of Scots became a liability to Scotland). Mary had to exit Scotland as quickly as possible to secure her freedom and life.

She sailed with sixteen retainers from Dundrennan Abbey, which is north-west of Workington across the Solway Firth. A sail of about sixteen miles in a fishing boat, and she landed, according to her secretary, Claude Nau, 'at this small fishing village on Sunday the 16 May 1568, just as the evening meal was about to be served'. A map of 1570 shows a group of fishermen's cottages in the Marsh on the south side of the River Derwent estuary, just below St Michael's church.

It is said that, as the queen stepped from the boat, she stumbled and fell, putting her hands on the soil of England — an omen that she had come to claim her right! Lord Herries, part of the queen's group that had escaped with her, declaring himself to have been a friend of the 'Laird' of Curwen, then sent a messenger up to Workington Hall for aid. He is supposed to have said that he had with him the future Queen of England (curious and somewhat dangerous words I would have thought?).

The queen's party would have then been escorted along the ridge path, which entered the hall gates from the west (today, Brow Top and its continuation of Lady's Walk,

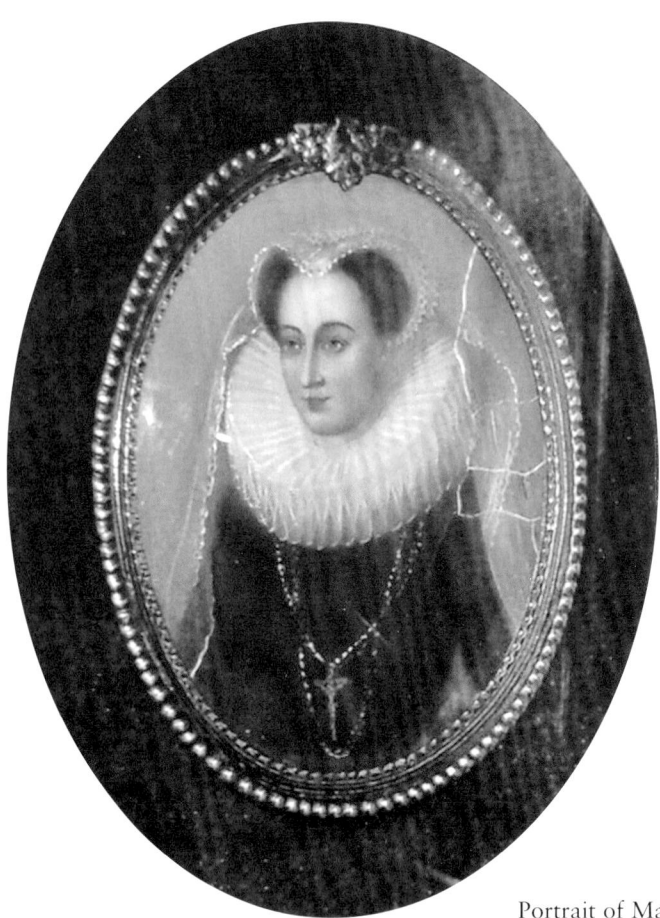

Portrait of Mary Queen of Scots.

which both run parallel with Finkle Street and Pow Street). Sir Henry Curwen has been recorded as being absent at the time and, according to a letter by Sheriff Lowther, he was 'in Bath with his Bedfellow' (a curious remark indeed). We know that people did not wash that often in those days, and records can refer to a person's young or second wife as his bedfellow, so can we assume that, when the queen arrived in the early evening, Sir Henry and Lady Janet were having their annual bath? Or was Sir Henry away in the city of Bath with his mistress? Or was it simply a throwaway remark by Lowther? (If he was in Bath with his mistress, then Henry Curwen must have returned in time to escort the Queen of Scots first to Hayton Castle at Aspatria and then to Cockermouth, from where she was collected by Sheriff Lowther with an escort of 400 troopers and taken to Carlisle Castle.)

It would seem that the queen's needs were taken care of by his mother and Lady Curwen, who 'gave her a change of linen'. The Queen of Scots had left Scotland with just the clothes that she was wearing (riding leathers?), so the ladies of the hall made her a number of dresses. It was from Workington, on 17 May, that the Queen of Scots wrote to Elizabeth I appealing for help and sanctuary.

A letter written in French addressed to 'Madam, my good sister' asked pity upon her extreme misfortune and was signed 'your most affectionate good sister and cousin and escaped prisoner, Mary R'.

Queen Elizabeth's reply to the letter of 17 May was addressed to the sheriff and magistrates of Carlisle (it seems that the two queens neither met nor corresponded throughout the nineteen years that Mary Stuart was in captivity). The letter, written on 19 May, reads as follows:

> By the Queen
> Trusty and beloved we greet you well, and for as much as we be informed that our sister the Scottish Queen is arrived within our realm at Workington in our County of Cumberland within the lordship and Seignory of our right trusty and right well beloved cousin the Earl of Northumberland who hath already sent certain gentlemen honourably to see to her entertainment and safe keeping in his our realm until our pleasure shall further be known. This is to will and command you and every of you as shall be appointed by our said cousin to see to her and her company well and honourably used as to every of them appertaineth; and also to see them in safety that they nor any of them escape from you until you shall have further knowledge of our further pleasure therein. Whereof we pray you not to fail as we especially trust you and as ye will answer to the contrary at your perils.

Orders to take the Queen of Scots into custody (and, note, 'if you let her escape you are in real trouble' — not that simple a task!)

The right trusty and well-beloved Earl of Northumberland was not to be trusted (as it happens he was away and therefore not consulted, but he should have been the person to take over the custody of the Queen of Scots). It was the Percys, earls of Northumberland, who, according to protocol, should have received the Queen of Scots and held her in Cockermouth Castle, awaiting the Queen of England's pleasure. However, they were Catholics, supporters of the Scottish queen and in argument with Elizabeth I. Despite the letter, they were obviously the wrong family to have the care of the Queen of Scots.

The Curwen's own history quotes Henry Curwen taking the Queen of Scots, lodging her overnight at Aspatria and then taking her to Cockermouth Hall, which at that time was the residence of Fletcher the banker. Here the ladies of Fletcher's family provided the Queen of Scots with red-velvet dress material. The following day saw Sheriff Lowther, with 400 troopers, collecting her. A small army, the 400 troopers were a warning to the Percys, and any other Catholic interests, to keep their distance.

Apparently, the Earl of Northumberland was late in hearing about the Queen of Scots' arrival in his Seignory, as after the queen had been a 'guest' of Lord Scrope in Carlisle for a week, along came Earl Henry Percy demanding from Sheriff Lowther that the Queen of Scots be handed over to him! (Demand refused.)

A few months later, when the Queen of Scots had been moved to Bolton Castle in Yorkshire, the Percys, the Earl of Westmorland, Dacre of Naworth Castle and other Catholic notables brought about the 'Rising of the North'. This rebellion had the avowed intention to 'liberate' the Scottish queen and place her on the English throne. The uprising was put down by the 'Men of Cumberland': Lord Scrope, with, no doubt, the aid of the Curwens and the Lowthers. Henry Percy was exiled and the Earl of Westmorland executed.

Although Henry Curwen was always referred to as 'Sir' Henry, he did not receive the accolade until 28 August 1569 (a belated reward for his actions in taking protective custody of the Queen of Scots and helping to put down the rebellion, wouldn't you think?) In 1570, Sir Henry Curwen was numbered with the knights who mustered at Carlisle in August of that year to make a foray into Annandale and Galloway. From this adventure they returned on the 29th of the same month, not having 'left a stone house standing capable of giving shelter to armed men'. As a trophy, he brought back with him the iron gates belonging to a tower of Caerlaverock Castle, which he erected on his gatehouse at Workington Hall, where they remained for over 300 years.

As for the unfortunate Queen of Scots, her flight to Workington led to nineteen years of captivity followed by her trial for treason at Fotheringhay and her execution. Workington saw the Queen of Scots' first steps on English soil and her last days of freedom.

Profit All Round?

There is even more to this argument between Elizabeth I and the Catholic earls of Northumberland. Over the fells in Keswick were the Mines Royal, German miners licensed by the crown to mine for copper and other minerals, with Elizabeth I taking a percentage of profits. Keswick, at the time, was a centre of industry. Workington and others had commercial dealings with the Germans, profiting from this 'royal' industry.

Fletcher, the banker of Cockermouth, handled the finances. The Curwens sold them coal (thirty horse loads); John Curwen sold them one ton of iron for £16 and an unnamed quantity of nails; John Curwen sold an Ulrich half a ton of Spanish wine; and George Curwen sold them ten quarts of vinegar at 5s. These were just some of the dealings Workington had with these German miners. In 1570, the Curwens leased a tract of land on Workington's shore to the Mines Royal. From there, they could import their timber from Ireland, and they used it as a store ground for the minerals extracted from the fells of Borrowdale and Newlands. Many people had a financial share in Keswick's mining industry, except the family who actually owned the Mineral Rights.

The Mineral Rights of this part of Cumberland belonged to the Catholic Percys. Elizabeth of England (as his sovereign) simply helped herself to the rights and gave the German company (and some of her loyal subjects) the commercial benefit of them.

The Lady of Workington Hall

In the Curwen papers there is a ballad (a romantic tale about a serving maid who becomes the lady of the manor). The story goes that a maidservant, whilst fetching water for the hall, meets with a gallant on horseback, who, after asking for a draught, departs singing to himself. The first verse is as follows:

> Who knows what may happen or what may befall?
> I may be … something she could not recall,

For the tramp of his steed mingled with the tone,
And the burden, ceased, broken — the singer was gone.

The last verse ends with:

But in vain! What the fates have determined will come!
And in time, tired of clangour of trumpet and drum,
Came the heir to the Hall of his ancestry old;
Met the maid of the Pitcher once more as he strolled,
Woo'd and won her, in spite of what'er might befall;
And made her the Lady of Workington Hall.

After a fashion, the story is quite true. For his second wife, Henry Curwen took the daughter of the Revd Crosby, vicar of Camerton. She was fourteen or fifteen at the time (as was the way in those days) and is referred to as a maiden or maid. A family pedigree of 1725 mistakenly quotes Henry Curwen as being married to Janet or Jennet Crosby, 'who was his Maidservant'. From this slip of the pen came the ballad (author unknown). It was this Lady Janet Curwen, the vicar's daughter, who, in addition to producing seven children, in May 1568, received from the Queen of Scots the so-called 'Luck of Workington'. This was the queen's own wine cup, and she left it to the family as a thank-you gift, as they had looked after her in her hour of need. The 'cup' is made of chalcedony and worked to be as fine as porcelain. Slightly larger than an eggcup, it is argued that it could have been the queen's own chalice.

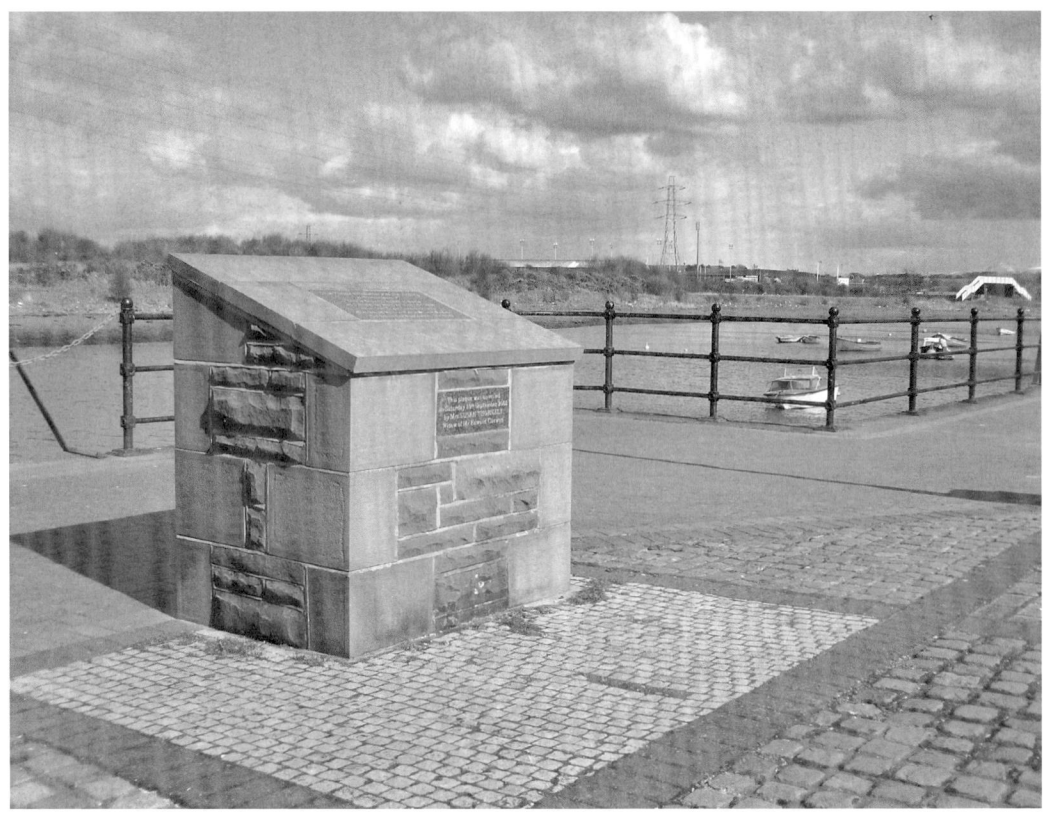

Memorial to Mary Queen of Scots' arrival.

Chapter 2

One That Did Not Get Away

William 'Foxy' Fowler the 34-year-old convict who made a sensational escape from Dartmoor and was free for 33 days before being dramatically recaptured by Flimby villagers on the night of June 15th, was back in Cumberland yesterday.

Such was the first paragraph of an article in the *West Cumberland News* for Saturday 29 June 1957. Brought from Durham Goal, he faced three charges at Maryport Court, all alleged to have been committed during the sixteen days he spent at Workington under the alias of Johnny Jackson.

Whilst serving a prison sentence, Foxy Fowler, allegedly a seaman and occasional burglar, escaped from Dartmoor Prison, in May 1957, by the simple means of climbing out of the toilet window. He braved the perils and swamps of Dartmoor, avoiding the police search parties, and, by stealing cars and a yacht, and taking the train, he eventually arrived in Workington via Manchester, Newcastle and Carlisle. His escape was financed by breaking into various premises, including a garage at Crosby on Eden.

Now, it seems that a few years previously, as Johnny Jackson, he had known the Moffat family of Workington, and in the Royal Oak Inn on Pow Street, he had met their daughter Margaret and her sister, with whom he went to stay on Garnett Crescent at Salterbeck. During the sixteen days he stayed there, he had looked after the children, travelled to Workington on the No. 48 bus and become a regular in the Royal Oak pub. (The great escapee, for whom the entire police force was looking, was living quietly and incognito on the Salterbeck estate!)

He also broke into Cresco Confectionery Co.'s premises and stole from a house at Crosby Moor to finance his stay in Workington.

On 15 June, after telling the Moffat family he was going to rejoin his ship at Glasgow, Foxy spent the evening at Workington Greyhound track and then stole a fishmonger's van from the car park and made for Flimby. (The fishmonger, incidentally, lived on Smith Road, also at Salterbeck.) Fowler, driving recklessly, almost hit Angus Boadle and Joseph Hodgson of Flimby as they were walking home from Workington. They were picked up by Billy Twentyman in his car, and when the three of them saw the fishmonger's van again, it was parked outside of the Long & Smalls Garage, which was closed at the time. They became suspicious and saw Foxy Fowler inside the café there. Sending for Norman Watson, one of the co-owners of the garage, the four men surrounded the building and challenged Foxy to come out quietly. Watson and Boadle grabbed Foxy as he came out of the door, cursing and lashing out with his feet and fists.

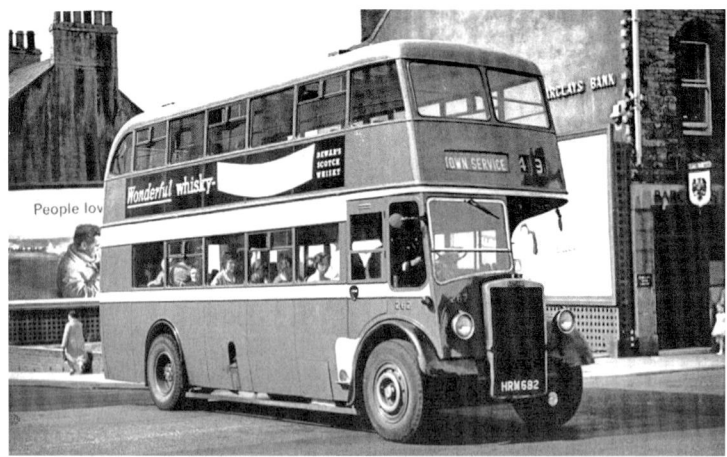
A number 48 bus.

Watson said, 'He fought us at first but Boadle got him in a half-Nelson and I held him down with my knee at his throat.' After a tussle, they overpowered him and sat on him. Police Constable Tyson of Flimby was sent for and he carried out the arrest of Fowler. On the way to Maryport Police Station, Fowler threatened to get the men, even if it took twenty years.

When Police Constable Tyson asked Foxy Fowler for his name, the reply was, 'You are all daft'. At Maryport Police Station, Fowler told Sergeant Gordon, 'I have no name,' and then he went on to admit to his real identity and the fact that he had escaped from Dartmoor.

After admitting to the various break-ins, William 'Foxy' Fowler was charged at Maryport, tried and found guilty of breaking and entering the Long & Smalls Garage at Flimby. He was eventually returned to Dartmoor. A few years later, there appeared a snippet in the local paper saying that Foxy Fowler had been found dead in a ditch. Had he served his time before meeting his death or had he again escaped but this time to meet an unfortunate end?

Chapter 3

Travellers' Tales

The first bus station built by the old Cumberland Motor Services was at Workington and opened on Friday 19 March 1926, with waiting rooms, offices and a café. The architect of this unique and one-off façade was a Mr H. Oldfield.

It was opened by the Mayor of Workington, Ald A. Baines, who announced that this was a historic occasion, for, only that day, the *Daily Mail* had reported that there was going to be opened in Glasgow the first bus station in Great Britain (a statement contradicted by the evidence before them); in fact, Workington was the first bus station opened in Great Britain!

Now, there was a little old lady who lived on Salterbeck estate whose minor claim to fame came about because of this opening day. She rode on the first bus that left the station on that opening day (No. 48). And, just because of that, whenever she took a bus, she told the conductors, 'I do not pay' — and indeed she did not! Despite all the protestations, the woman would not pay and got away with free bus travel until the end of her days. Quite true!

In Yorkshire, it is a case of 'eat all; sup all; pay nowt, and if you ever do anything for nowt allus do it for thysen'. In Workington, the case is 'owt for nowt … and two pence change'.

Made in Workington

In 1969, Leyland of Lancashire originated a bus-manufacturing plant at Lillyhall and in the years of production, from 1971, introduced a number of prototypes. The first British 'Bendy Bus' was produced at Lillyhall. Basically, two full-sized Leyland National coaches joined together with a flexible concertina coupling — a bus that bent in the middle for turning corners!

Curiously enough, this new prototype for the national bodywork was developed in secret. So secret that, when it was driven down to the Leyland plant in Lancashire for the fitting of seats, etc. the gatemen refused admittance to the vehicle until they were assured by phone calls from one of the directors of Leyland that it was indeed a Leyland product.

In 1978, another Leyland Experimental Vehicle was created. This was the 'railbus' and, with a driving cab on each end of a national coach body and mounted on a four-wheel underframe supplied by British Rail, it was the forerunner for the pacers and diesel multiple units that still operate on the railways today.

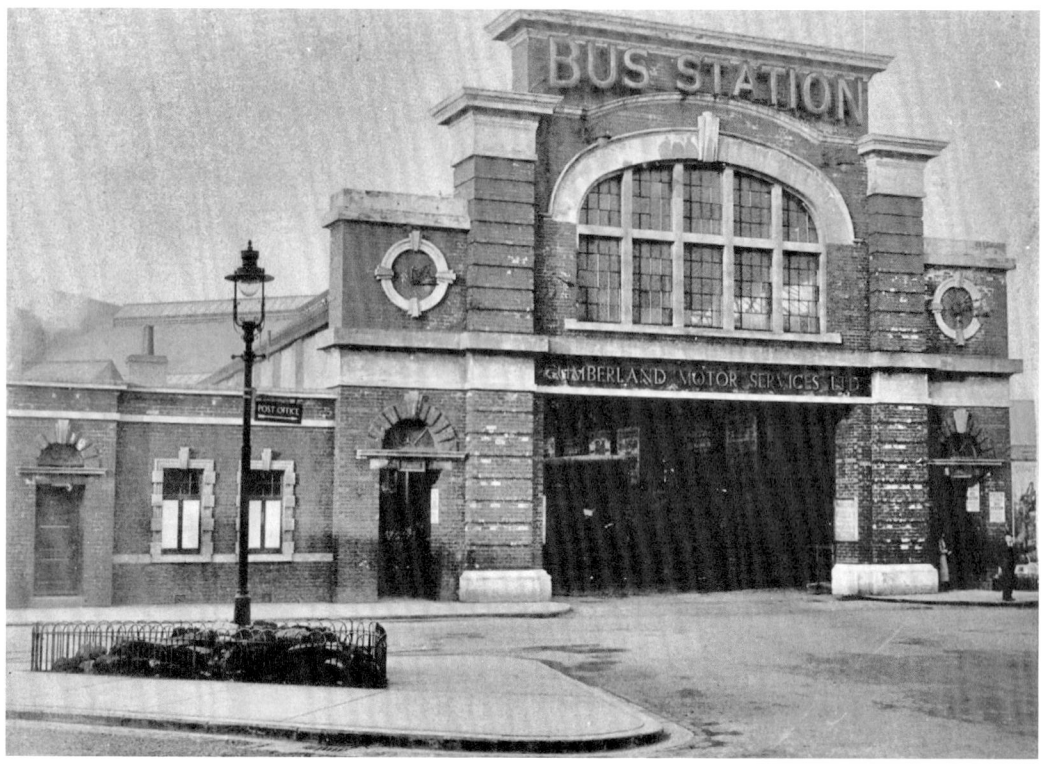

The unique bus station in 1926.

During the production of the Leyland National, and to assess the strength of the national coach body structure, one of the prototypes was deliberately driven to collide with a 100-ton block of concrete at 20 miles an hour. Prototype B701 passed the test with flying colours, suffering only a little deformation. Strange, but true!

Chapter 4

Inventors and Inventions

Workington has had its inventors, those people with an inquiring, scientific or a mechanical turn of mind.

A good pint (and there is nothing like a good pint), I am assured, relies on the cleanliness of the pumps and pipes, and in April 1932, the 'Lawson, McKenzie Beer Pump and Pipe Cleaner' was the name of an invention for which a Workington firm had applied for the patent.

The gadget was the joint effort of Mr T. G. McKenzie, licensee of the Central Hotel, and Messrs Ogden and Lawson of the Solway Brass Works. It was designed for the cleaning of the pipes that led from the beer barrels in the cellar to the pumps in the bar of the hotel.

Previously, the cleaning of these pipes necessitated one man in the cellar with buckets of a soda solution, which another man in the bar pumped through them. Because of the soda solution being used, the pipes had, of course, to be thoroughly rinsed out afterwards. This new appliance, with cocks and valves, allowed a pipe to be fixed to a tap and water to be passed through at high pressures, and this meant pipes could be cleaned in minutes. The system was, of course, extensively taken up by the bar trade. So all you imbibers of good English ales can thank the licensee of the Central Hotel, Workington, for being able to enjoy a good pint!

Television in 1932

It may sound unrealistic and it will surprise the majority of people to realise that television pictures were being received in Workington in 1932, four years before the BBC opened its first public television service and twenty-five years before television came to the masses. However, it is quite true.

Harold Dunn, a motor engineer with a garage in Workington, dabbled and tinkered with this new invention and built himself a home-made set from bits and pieces of car spares. Driven by a car battery, the television picture was little larger than a postage stamp but magnified by the lens taken from the oil lamp of an old Morris. The picture came through in pink (colour television?)!

Those early Baird experimental transmissions from Crystal Palace were supposedly of a 50-mile radius, but here in Workington, 300 miles away, the Dunn family were enjoying the pictures transmitted on a set which utilised car spares. The BBC were not for believing this contraption, but after sending an expert to Workington, they had to admit the genius of this home-made marvel.

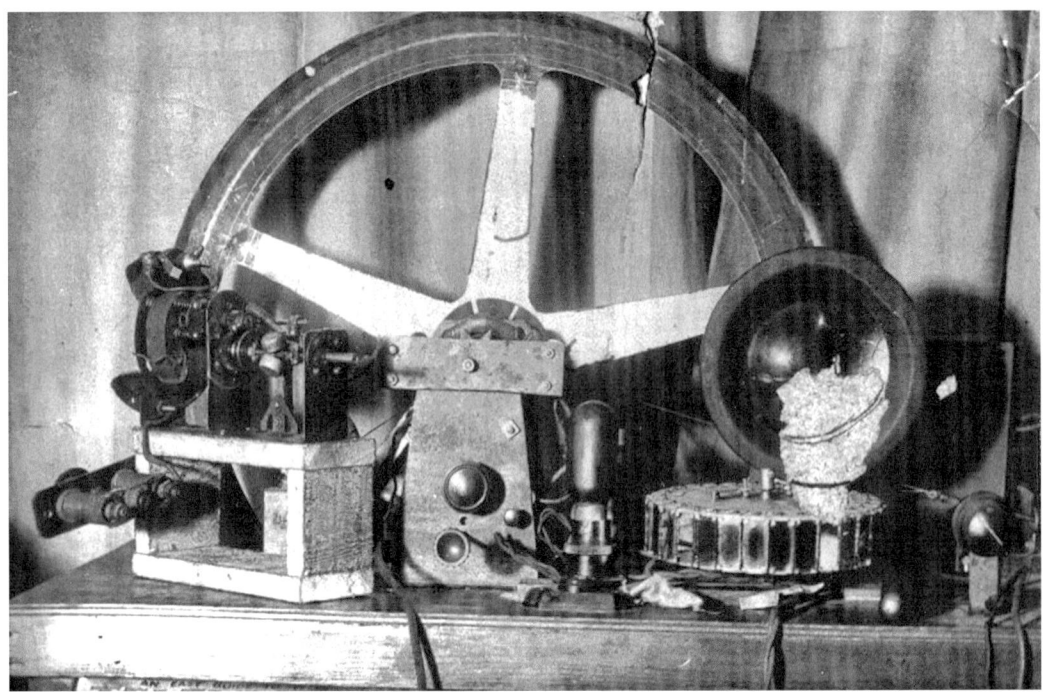

The television set of 1932.

Chapter 5

Pubs and Drinkers

As Dr Johnson once said, 'Nothing contrived by man gives so much happiness as an inn.' The British pub is the home of free speech, and on any day, you can find groups of people in pubs expressing their views and putting the world to rights.

Workington originally had many pubs, for in 1901, there were no less than eighty-seven public houses and five beer houses in the town itself; previous to the twentieth century, there had been even more. Victorian law, with its curious propensity for licensing and taxation, stated that a respectable citizen could, by obtaining a licence for £2, sell beer and ale from his home. Some of these licensed dwellings eventually developed into local taverns or inns.

It is interesting to look at nineteenth-century directories, which show inns that had disappeared by the mid-twentieth century. The Three Anchors were lost at sea; the Three Grapes were squashed; the Moulders Arms, reshaped, perhaps; the Greyhound, King Street, had run away; the Highland Laddie had, perhaps, returned to Scotland; the Spread Eagle had flown away from the Market Place; and was the Pineapple eaten? And whatever happened to the General Suwarrow and the Indian King is anybody's guess.

The part of Workington with the largest number of inns on its streets would appear to have been the working class district, which was at the lower end of town, centred on Derwent Street, Church Street and Griffin Street. Admittedly, there were eight inns in the vicinity of the Upper Market Place, but these three streets between them had thirteen public houses and two beer houses. (All disappeared in the 1970s.) Workington's oldest inn would appear to be the Nags Head. The earliest date, inscribed in stone, is 1669, but, apparently, the lower site was that of an earlier inn known as the Flying Cat (note that a 'Cat' was a small fishing vessel or a tender). Today, the pub is a crèche! (How is that for a curious re-use of an establishment?)

Some of the pubs on the Marsh and Quay that attracted those ladies of easy virtue had reputations of being 'knocking shops'. The Grapes on Church Street was said to be such a rough spot that the women used to put their prices on the soles of their shoes!

Many publicans also had secondary businesses. The present Miners Arms on Guard Street, originally known as the 'Guards', had a landlord by the name of Joseph Sherwood. This pub was very useful if a drinker had a cash flow problem, as Joseph also ran a pawnbroker's from another room in the pub. The Royal Oak, Pow Street, sold shoes, and the Bessemer Arms had Anthony Story as both a publican and a barber (going for a haircut is a much better excuse than taking the dog for a walk). A lot of innkeepers also sold groceries to supplement their income.

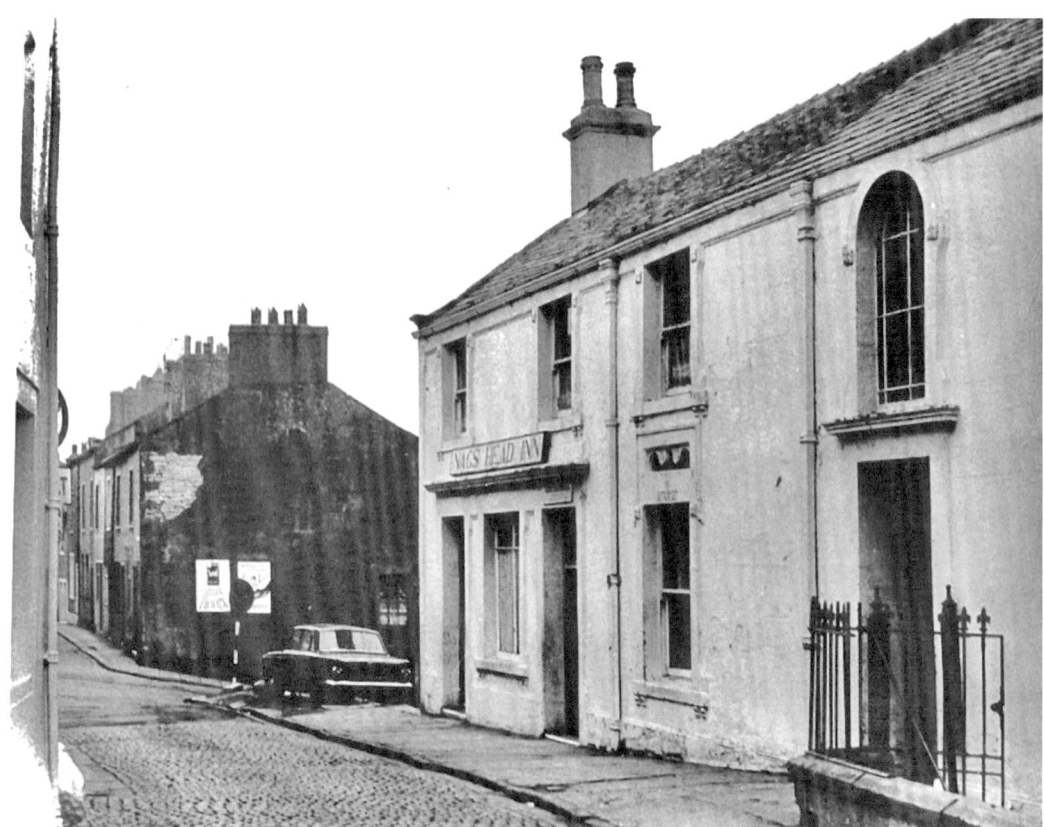

The Nags Head. Workington's oldest pub.

A Curious Case of Bad Beer

It was the winter of 1900. Victoria was on the throne, and in Africa the Boer War was in progress, but in parts of Manchester and Workington an unusual epidemic was raging. It was an illness that had the doctors baffled and, for want of a name, it was just referred to as the 'Foot and Hand Disease'. The symptoms were swollen feet, swollen faces, sore eyes, aching legs, and the skin peeling off both feet and hands.

In Salford in Manchester, fifty-one deaths were reported, whilst in Workington, an undisclosed number were either dead or on the point of death from this enigmatic illness. When the disease reached epidemic proportions, Dr McKerrow, the senior Workington physician, went to Crumpsall Hospital, Manchester, to see the suffering there and to seek the cause of the problem, which was eventually found to be that of arsenic poisoning. This caused a furore; was there a mass murderer on the loose? Investigations showed it was worse than thought possible: it was the beer! The brewing sugar that had been supplied to two breweries had been adulterated using 'white arsenic'.

The Workington brewery affected was the John Peel Brewery, who had a large number of pubs in the district, so you can imagine the consternation this caused the drinking classes as well as giving the police even more Saturday-evening problems.

On Ritson Street, in the small building known as the Roundhouse, can be found the Lock Up Shop, a basic cell, built, in 1825, 'by public subscription'. This, the local jailhouse, was just around the corner from the police station and, in its day, held many a petty felon and drunk. During the winter of 1900, it saw a great deal of use, because regulars, having changed to drinking spirits, created even more cases of drunkenness. The courts were kept busy at this time, with the police even more active transporting drunks to the 'Lock Up' on Ritson Street in a handcart, which was the only transportation the police force had at that time. Gladstone Street police station, which was sited at the bottom end of town, was in a house, with certain rooms used as the office and cells; this too saw an increase in its number of 'lodgers'. In those days, the occupant of the house and police station was Police Sergeant Patrick Wells, known to all as 'Paddy Wangs'.

He apparently suffered from flat feet and left his bootlaces undone most of the time. When called out to attend an incident, it was a case of, 'hold on a minute while I fasten me Whangs' ('whangs' was a local term for bootlaces).

Jennings Brewery of Cockermouth, whose beer was not affected, stepped in with supplies to help the Workington pubs over their 'drought', but it was quite a while before drinking habits were restored to normal. The John Peel Brewery was given a complete clean out, and sugar stocks were replaced. In Manchester, the medical authorities analysing samples of their beer found arsenic in considerable quantity, 'though the samples of Stout were not affected'. Cheap sweets and jams taken for analysis were also found to contain arsenic in quantity.

Adulteration of foodstuffs in Victorian times was not uncommon. The brightly coloured sweets (gobstoppers, etc.) received their colours from the use of 'copperites', another poisonous substance. Although not poisonous, additives such as roasted parsnips, scorched beans or peas and acorns were included with ground coffee beans to create a new and popular drink. Dried strawberry leaves could also be found in packets of tea. (*Caveat Consumpter* — Consumer Beware!)

Workington Brewery originated in the nineteenth century when the land known as Shortcroft was bought from John Christian Curwen by his solicitor Mr Thompson. In 1839, this company then sold the property to the Iredale brothers, who built the Workington Brewery. It was in 1929 that the famous John Peel Ales were first brewed, giving the brewery its distinctive name.

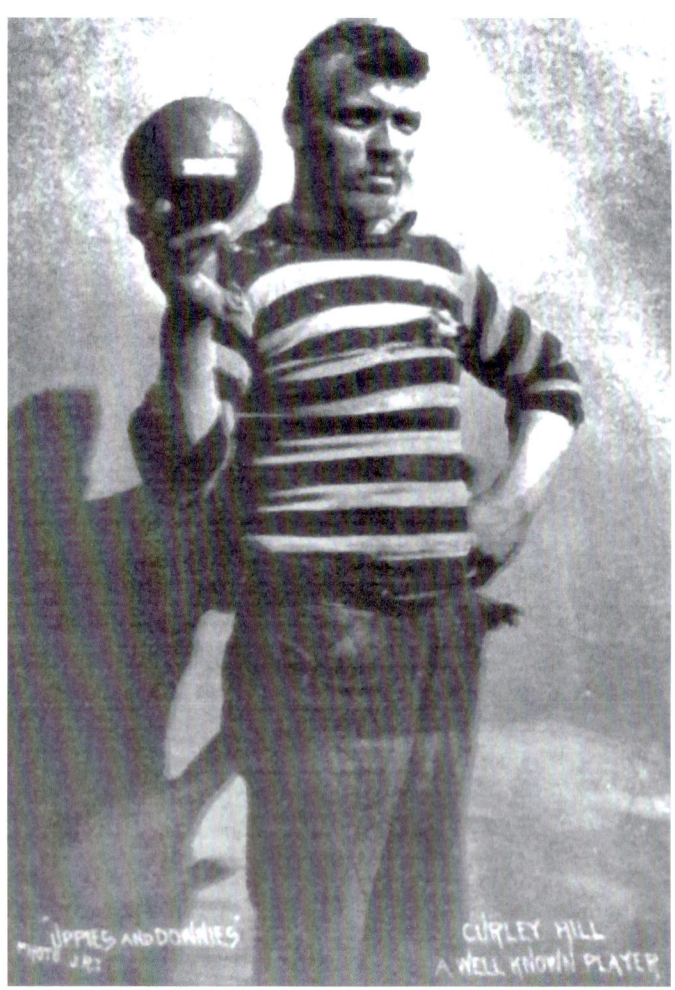

An Uppies and Downies player of the early twentieth-century on Curly Hill.

Chapter 6

The Uppies and Downies Game

One of the oddest things about the town of Workington is the playing of this traditional game. Workington is just one of three towns in England that still plays this 'ball game'. It is an annual activity that appears to go back to Saxon times or even earlier. How did it come to originate? It is known that the Celts were headhunters and that the Anglo-Saxons quite often played football with their enemies' heads. The Vikings, for that matter, used their skulls as drinking bowls! Are these the origins of this annual game? Workington plays its game at Easter, an important time of the year in both Christian and pagan cultures.

Referred to as the Easter Game, it has been a sporting activity for centuries and one in which the whole populace (omitting women) can take a playing role. As a mass football game the ball is never kicked (unless you want to suffer a few broken toes that is), being made of hand-stitched leather, slightly smaller than a football and stuffed with flock; however, in earlier hand-made balls sawdust was used. None of these Uppies and Downies balls are lightweight!

There are also no rules and no teams, the pitch is three quarters of a mile in length, and the town from Merchants Quay on the docks to the Hall Park in the upper town becomes a mass of struggling males attempting to manoeuvre the ball one way or the other — no holds barred. In the nineteenth century, it was, more or less, a theoretical contest between the mariners and the miners. The ball is hailed (thrown up in the air) from a bridge over Brewery Beck in the centre of the Cloffocks. It is then passed by hand (or manipulated by any other means) towards the upper town or the docks, to be hailed again as a means of scoring. Although the game was expected to travel up or down stream, it quite often spilled over into the town causing consternation, broken windows and, on occasion, broken limbs. (Recent building developments within the town are, unfortunately, at present strangling this traditional game.)

A game can take anything up to six hours before the ball is hailed. Playing in the dark is nothing new, with shouts of 'up wid her' and 'down wid her' giving an indication as to where the ball is. The shortest game on record was on Good Friday, 1930. The veteran player Anthony Daglish threw off (hailed) the ball at 5.04 p.m., and it was Thomas Clague who, after receiving the ball from a long pass, legged it for Workington Hall without any opposition and 'hailed' it at 5.20 p.m. by ringing the old ship's bell, which was mounted on the gateway.

The Downies had been done! Because the throw off was not supposed to have been until 5.30 p.m. Easter Tuesday saw a crowd of at least 15,000 cheering Anthony Daglish

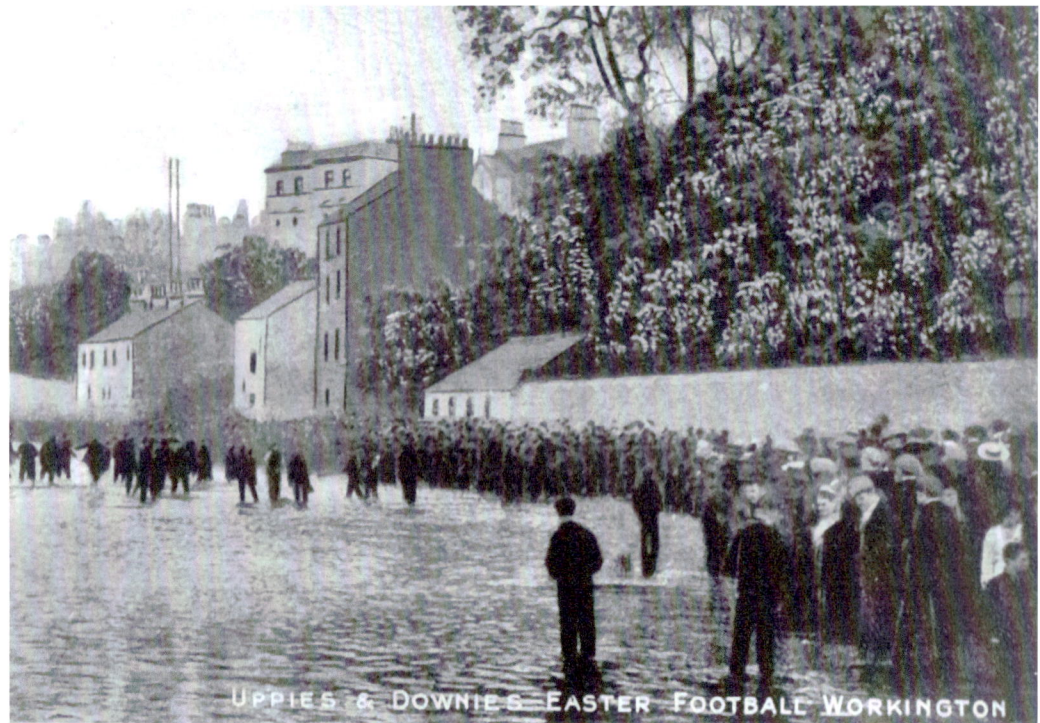

Uppies and Downies played on a flooded Cloffocks.

as he again hailed the ball. As the scrum moved towards the town, a body of police successfully turned it aside. In the beck, families, such as the Stoddarts, Donackleys, Hills, Milligans and Daglishes, were fighting for possession and the ball thrown out from the scrum was collected by a seventeen-year-old Downie by the name of Eric Herron, who sped off downstream. He was tackled, and the scrum reformed and slowly moved towards the harbour, where a boat was obtained. After a fight, waist deep in water, young Herron and a veteran player, Ned Donavan, rowed to the jetty to hail the ball at the capstan for the Downies.

Thousands turned out again on the following Saturday for what was an even fiercer battle of about three hours' duration. At one point, the police had once again to turn the scrum away from the town. A police charge moved them away from Dolly's Brow, and had the game gone into this part of town, it would have overwhelmed the open market on Hagg Hill and panicked the shoppers and stall holders. The ball was worked back to the starting point and then slowly moved towards the River Derwent, swum across by Jack Graham. Chased by Downies, he made for Northside village only to be tackled by a resident who took the ball down towards the docks where it was hailed by J. McAllister.

The ball was hailed twice by an earlier Mr Daglish (Anthony's father?) in 1871. Twenty minutes was enough to secure a win for the Uppies. As the men were leaving the hall grounds, a Mr William Litt asked Mr Daglish to have another 'do', promising

him 5s if the struggle was renewed. It was agreed to play again. The game was this time mainly on the banks of the River Derwent with Bob Fisher, a butcher from Harrington, throwing the ball to Mr Daglish, who once again hailed it at the hall. The men got their 5s from Mr Litt! 'And,' as Mr Daglish observed, 'Five Shilling was Five Shillings then; – A shilling was good for Six Pints of Ale.'

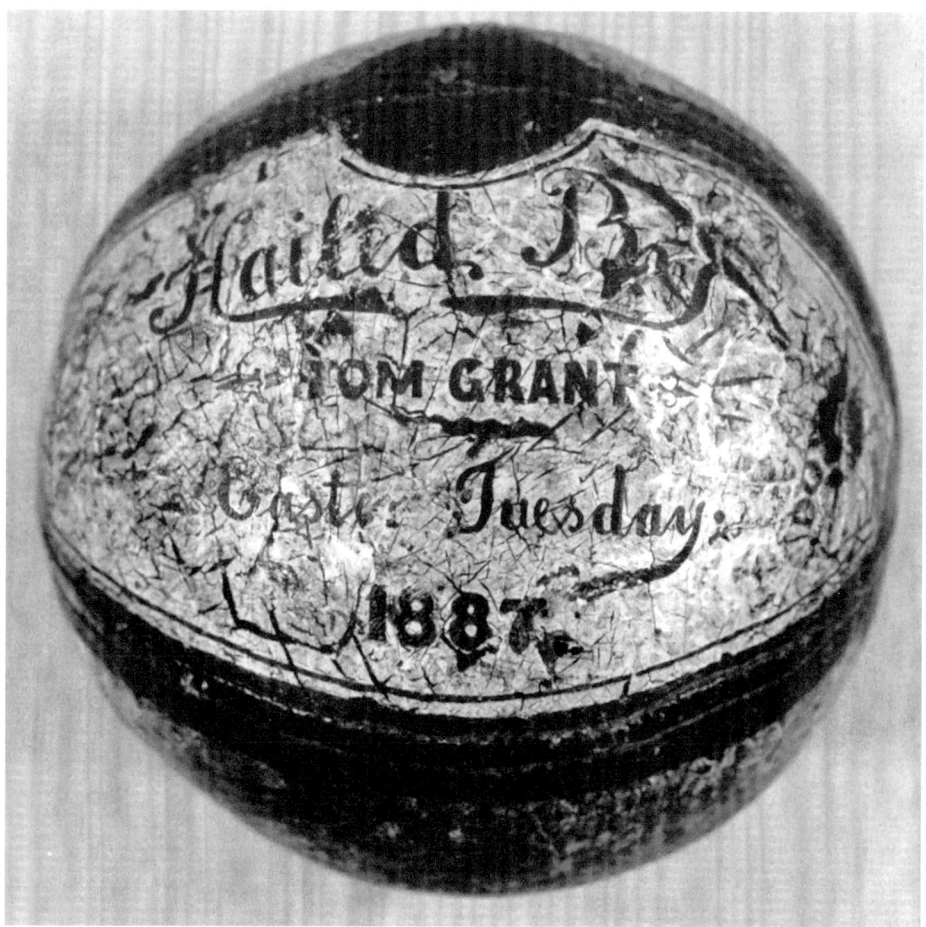

The Uppies and Downies ball of 1887.

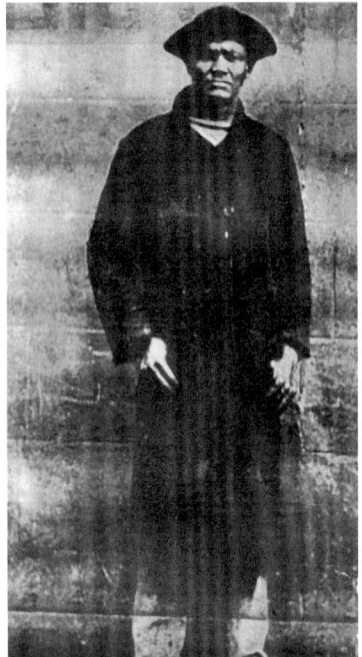

Left: Darky Joe from Chicago c. 1905.

Below: Boots used on the Marathon?

Chapter 7

The Great Marathon of 1903

Workingtonians were great sportsmen — or were they? Events frequently involved rivalry between the villages and towns. Occasionally, there was an off-beat event that raised enthusiasm and competition to fever pitch; such was the great walking race of 11 June 1903.

The walk was another idea of 'Cousin Charley' (James Bleasdale of the *Cumberland Times* newspaper). 'Charley', in addition to writing the children's page in the *Cumberland Times*, promoted various events, one of which was flying over Cockermouth in a balloon during the Children's Galas, also organised by the newspaper.

The walk was to be from Workington to Cockermouth, then on to Maryport and back again to Workington. A Broughton entrant claimed that he had already done this at a pace of more than six miles an hour but, as the walker came from Broughton, no one wanted to believe him. Seventy entrants went into very strict training, even giving up beer and tobacco. John Carter of Broughton Cross (as a regular road racer) was the favourite to win, but Workington's dark horse (literally) was Darkie Joe Johnson.

Originally of Chicago, Darkie Joe was born around 1852 and had arrived in Workington the previous year as a fireman on a cargo vessel. He had an accident in the stokehold of his ship in which his feet were scalded, and by the time he had recovered from his injury, his ship had left. A man in the prime of his life, and reputedly over six feet of lean bone and muscle, he settled down in Workington as a labourer, lodging first on Vulcan's Lane, then later in Church Street.

The seventy entrants dropped to forty-eight racers. A motley crew, they were aged from nineteen to fifty-eight; they wore Panama hats, straw boaters and German caps, cricket shirts, running drawers, flannel trousers and knickerbockers. As for footwear, Darkie Joe wore galoshes, with most of the other walkers in boots and clogs, and a minority in thin-soled 'spring' boots.

About 2,000 people turned out to see them off, and the race was accompanied by a mass of cyclists (cycling was the other favourite sport of the day). Following behind this cavalcade was a wagon loaded with flasks of the latest new savoury, energy-providing drink: OXO.

The race started from Low Station to great cheers as Darkie Joe took the lead. Only fifteen made it to Maryport, with Darkie Joe having to retire at Dovenby. At Grasslot, John Corlett, who came from Cleator Moor, was given a drink (a rather large brandy), supposedly to energise him, but which sent him to sleep by the roadside. One of the

A cyclist from Harrington – did he follow the walkers?

favourites to win, he had been 'nobbled'. (I should point out that the local bookmakers were also present at the event and apparently active!)

Another competitor was also knocked out by a brandy, but as this walker came from Broughton, the race officials refused to acknowledge this as a case of 'nobbling'. (What did they have against these lads from Broughton?)

The winner was a W. H. Hetherington Kay from Embleton, who completed the course of 22 miles in 3 hours, 59 minutes and 38 seconds, with Bill Mears of Workington in third place and Billy Blacklock, also of Workington, taking fourth. John Carter of Broughton Cross came in second. The average speed was about five and a half miles an hour.

The Great Marathon of 1903

The high turn out of cyclists on that day showed the popularity of the sport and also supported the fact that Workington had no less than seven cycling clubs, with occasional cycle races held at Lowther Park Stadium. Two years later, the Good Templar's Association also held a walking race; entrants were strictly teetotallers!

* * * * * * * * * *

OXO, of course, became a household name, but I wonder what today's Trade Descriptions Acts would have made of this advert, which was prevalent at the time.

HOLLOWAY PILLS

BE OF GOOD CHEER...THAT SINKING FEELING MAY BE SAVED.
HOLLOWAY PILLS ARE A REMEDY FOR:

Disorders of the Stomach ...Women in All Difficulties ... Strength and Vigour ... Disorders of the Liver ... HOLLOWAY PILLS for Ague ... Asthma ... Bilious Complaints ... Bowels ... Colic ... Consumption ... Debility ... Dropsy ... Dysentery ... Fits ... Gout ... Headache ... Indigestion ... Jaundice ... Liver ... Lumbago ... Piles ... Rheum ... Sore Throats ... Tumours ... Ulcers ...Venereal Diseases ... and Worms.

PRICES — 1s/1d ... 2s/9d ... 4s/6d ... 11s/2d ... 33/-

* * * * * * * * * *

The Voice of the People

Whenever raised and for whatever purpose, must always
Command the fullest attraction and respect.
Whether the subject be imperial, national, industrial, or domestic,
"This Voice of the People" holds the sway.
This Voice it is that for nearly sixty years has consistently sounded the praise of

BEECHAM'S PILLS

a medicine of which the people have long known the remedial value in

BILIOUS & LIVER DISORDERS,
SICK HEADACHE,
FAILING APPETITE,
LANGOUR & WANT OF TONE

Caused by depressed conditions of the nervous system.
In all such cases it is not too much to say that
The benefit to be derived from a judicious use of

BEECHAM'S PILLS

Is practically known all over the world.

Sold everywhere in boxes price 1s.1.d (56 pills)
And 9s.9d (168 pills)

WORTH A GUINEA A BOX.

Beecham's Pills: the cure all.

Chapter 8

An Involvement with Beecham's Pills?

Whilst this is a curious tale of Windermere, it goes to show the civic pride of certain Workingtonians and their wish to preserve this county of Cumbria as it is.

As everyone knows, it is not the done thing to erect large advertisement hoardings in Lakeland. People who live in the lakes are a pretty conservative lot and most of them are dead against anything which would spoil the natural scenery of the area, with the result that anything bigger than the most discreet 'Bed and Breakfast' sign is frowned upon. Big, flashy display advertisements are not the thing for the Lake District; however, there has been the odd attempt to break through the defences of the conservationists, with disastrous results. That there were people prepared to risk prosecution by destroying advertising signs in the days when such signs were not illegal is as important to the history of Cumbria and the Lake District as the fact that there are those people willing to risk the wrath of landowners by invading privacy and disturbing livestock on what they consider to be public footpaths.

Trouble started at Windermere in July 1890, when an over-eager representative for Beecham's Pills, by the name of Mr Challoner, erected, at Bowness Bay, and with it facing into the lake, a huge board declaring to the world the efficiency of the little yellow pills. The board proclaimed the slogan — now famous — that nobody ever challenged: 'Worth a Guinea a Box'.

The publicity board was erected on the Tuesday, a very astute move by Challenor because it meant that everybody in the rising sport of yachting could hardly miss it as they sailed past. That night, it was pulled down by a person or persons unknown! Two days later, the advertisement was replaced, larger than before. As had already been detected, there was some local resistance to the advert, so Mr Challenor requested the services of the local police to watch over the board, so Superintendent Shield provided a policeman to guard it!

A Constable Hastwell was on duty watching the board at 1.00 a.m. on the Friday, when he saw a small boat come to shore. Out of it got two men, who started to saw through the post. As the constable approached, however, the two men made their escape, and although it was a bright, moonlit night, the policeman could not give a description of the culprits.

Mr Challenor's determination to tell the world around Windermere (as if they did not know already about the miracle pills!) was next manifested in the purchase of a yacht, which he intended to sail around the lake; on the sails of the yacht was painted the Beecham slogan! This yacht was sunk at her moorings, whilst she was anchored among

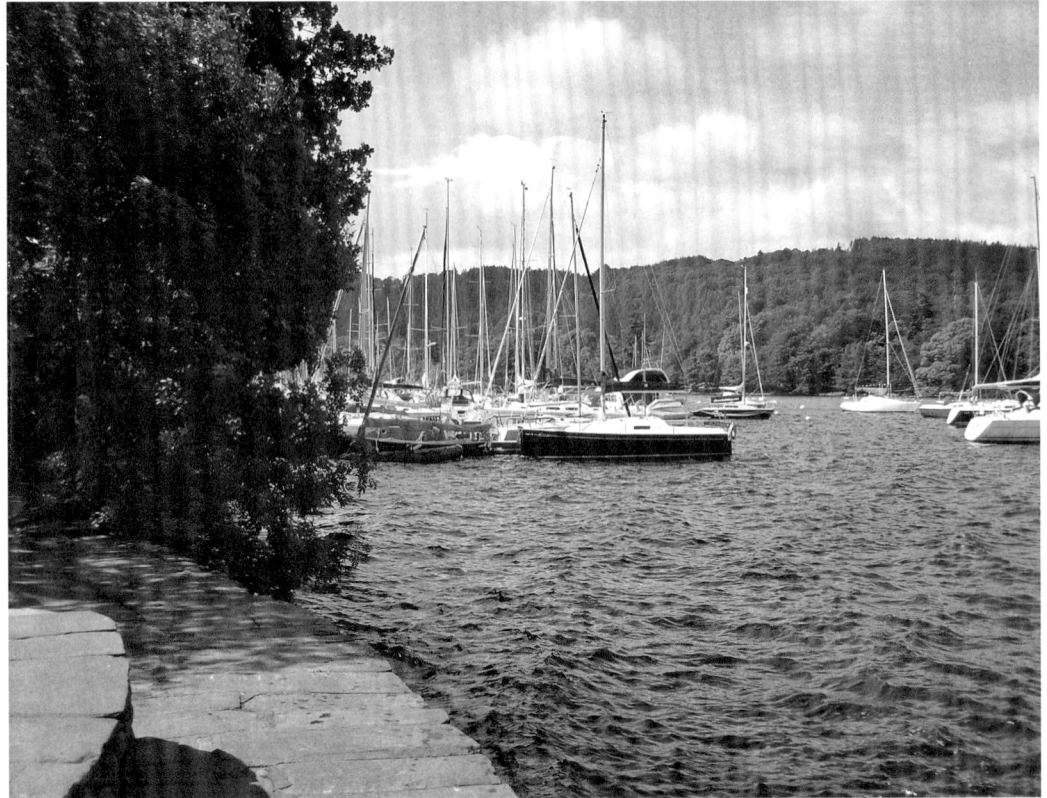

The yachts at Bowness Marina.

the other yachts at the Yacht Club. (Someone had bored a hole in her with a brace and bit!)

The large sign still remained at Bowness Bay and still with police protection, and on the Wednesday, after the sinking of Mr Challenor's yacht, Constable Armstrong saw a boat come to the shore. One of the men got out of the boat and commenced to bore holes in the post of the advertising board. The constable quickly moved in and captured the man with the drill, and as the marauder's companion left the boat to help his mate, Police Constable Hastwell appeared on the scene.

There was a struggle before the two men were overpowered and handcuffed, but the constables still did not know who they were. Both raiders had blackened their faces and in addition to the brace and bit also possessed two cartridges of gunpowder, a small box of gunpowder and a length of fuse. They obviously intended to blow the offending board up in a spectacular manner.

Taken to the police station, they were eventually identified as Alan de Lancy Curwen and his brother, Edward Darcy Curwen, both sons of the great family of Curwen of Workington Hall, who were then residing at the Curwen's other home of Belle Isle, Windermere, in plain sight of the Beecham's Pill advertisement. (Within ten years, Alan de Lancy Curwen was to become the lord of the manor following his father's death).

An Involvement with Beecham's Pills?

They were locked up for the night and bailed out the next morning with the sum of £50 each. It says something for local feeling in the case that when the pair appeared before the magistrates, and despite the fact that Beecham's had briefed London Counsel for the prosecution, they were only fined £2 each. They were, however, informed by Mr Wakefield, the chairman of the bench, that if the damage had amounted to over £5 when committed, the case would have gone to the Quarter Sessions where they would have been liable to a penalty of up to five years in prison.

In the meantime, the secretary from the Bowness-on-Windermere Association had written to Mr Beecham himself:

> This was the first notice of the kind that had appeared on the shores of Windermere, and there was a very strong feeling on the part of visitors and residents against the 'innovation' and under the circumstances he hoped Mr Beecham would kindly defer to the wishes of the people and give instructions to his agent to have the advertisement removed. A course of action on his part which could not fail to commend itself to public opinion.

The offending advertisement was removed, but they never did find out who scuttled Mr Challenor's yacht!

Chapter 9

On Matters Medical

Workington needed a hospital! The town had two railway stations, a gasworks, a few coal mines, quarries, ship building, steel production and farming.

Victoria had been on the throne for forty-six years; Dickens was drawing attention to the plight of the poor, sick and elderly; and Florence Nightingale had established a nursing school from which trained nurses were entering into provisional hospitals. But Workington had no hospital or infirmary, just a dispensary, with several panel doctors, to cater for a town whose population was ever increasing.

The cholera epidemic of 1849 had been followed by a lesser one in 1860, with the local doctors once again struggling to control the disease. Curiously, the epidemic had been centred on the streets just below St Michael's church — Church Street, Brewery Street and Griffin Street — which clustered around the unsanitary Brewery Beck. Whilst this beck was obviously the cause of the disease, the local authorities, in 1860, blamed the brewery for having polluted the beck with their 'waste pourings'. Dr A. Peat was reasonably successful in fighting against the prevalent diseases of those days, which led to him becoming the chief medical officer. He was also rewarded for his sterling work with the erection of a memorial to him in Portland Square. (However, I doubt if his methods would have met with approval today!)

In Griffin Street, he had a patient suffering from smallpox, so the good doctor's cure was to put him to bed, cover him with blankets, close all the doors and windows to the room and stoke up the fire. Dr Peat then sat up all night with the patient, with himself puffing away on his pipe. (Whilst the patient sweated away the disease, the good doctor fumigated the room!) After a couple of days' rest, the patient was cured. With most common ailments in those days, especially influenza, it was the norm to 'sweat it out' (go to bed with a hot drink, and an aspirin), which in most cases worked. Another favourite cure of Dr Peat's was to allow the patient sufficient brandy or whisky (without the patient getting drunk) to produce a good sweat. Dr Peat was both successful and popular.

In the 1880s, those needing hospital treatment were sent to Carlisle or Whitehaven hospitals by train or horse ambulance. In one emergency, a severely burnt man from the steelworks was taken to Whitehaven in a horse-drawn bread van! Needless to say, he did not survive the journey. The average stay of a patient in hospital in those days could be six weeks at a cost of 19s per week, and there was also a charge for the use of a van or train journey, whichever applied. Medical treatment then was expensive, so, after many arguments, the populace of Workington decided the town needed a hospital, and they went ahead and built one.

On 7 July 1884, a meeting was called in St John's parish rooms to consider the building of an infirmary. Representatives from the churches, friendly societies and trading establishments were all invited and it was agreed that an infirmary be built at a cost of £2,000.

On 31 August 1885, Mr Edward Darcy Curwen laid the foundation stone, and Mrs A. Wilson of Sheffield performed the opening of the hospital on 29 November 1886. The final cost was £2,736 1s 6d. It was funded entirely by contributions from the people of Workington, and the local telephone company also installed the telephone for free!

The matron was a Miss Galloway, with one day-nurse and one night-nurse in attendance for a total of eight beds in Curwen Ward and four in Wilson Ward. 1888 saw another four-bed ward for female patients, and 1932 saw a maternity ward opened by Helena Thompson, the local benefactress (this ward had six beds, two private wards, a labour ward and all services). Previously, in 1925, Miss Helena Thompson of Park End Road (her former house is now the local museum) installed the first wireless set, a five-valve set with twenty-two headphones and three loudspeakers.

These were the days of strict hygiene and medical discipline. Many were the rules and regulations for the running of a very efficient establishment. To quote one of the many rules:

> Patients will be responsible for the washing of their own clothes. And patients will also provide themselves with a change of Linen. Any Profane, Abusive, or Immoral Language or behaviour will be punished by 'Dismissal' from the Infirmary.

The committee agreed to the nomination of a ladies' committee to assist with domestic arrangements (all volunteers). Mr G. Graham, treasurer, then instituted a scheme

Workington hospital.

whereby each workman paid 1d per week (later increased to 2d and then 3d). This was taken from his wages and entitled him to free medical treatment in the infirmary. Was he aware, I wonder, of John Christian Curwen's eighteenth-century health service? This, again, was one of the first such schemes in the country in the late nineteenth century.

The income for the infirmary for the first year was a very healthy £930 4s 7d, of which £568 17s 6d came from workmen's contributions.

These steelworkers' contributions continued to be the main source of income until the establishment of the National Health Service in 1948. In fact, Workington was one of the very few hospitals to be taken over in possession of a strong credit balance.

In 1915, all other members of trades and the general public were invited to join this 'penny a week scheme'. As the public notice said (in part):

In the case of NON SUBSCRIBERS, the MINIMUM HOSPITAL CHARGE is 30 shillings per week and no patient can be admitted until terms are arranged, except in the cases of accident or emergency. The Committee respectfully urge all employees and workmen to become contributors to the infirmary, so that they may be entitled to use of the institution when required.

In 1889, the income of the infirmary had risen to £1,318 18s 3d and the grounds were planted. Two beds were kept on standby for emergencies (hospital beds, that is, not flower beds.)

In 1890, the matron, a Miss Winter, made it known that she would welcome parcels of old linen for surgical cases. The yearbooks show the generosity of the people of Workington towards their own hospital; donations were made by individuals, churches and companies, and gifts of money ranged from 2s to large endowments. Parcels of books, cakes, sweets and fruit, toys, poultry, clothing, eggs and flowers were regularly accepted. Children held concert parties on the shore during the summer, with the collections going to the hospital. Street Parties were held, an excuse for celebration, with, again, the proceeds going to the hospital. On 25 June 1914, the town held the first Alexandra Rose Day. A Floral Fête was held at Lonsdale Park, with a carnival, sports, entertainments and a horse show. Railways operated special trips for this event, bringing in visitors from Egremont, Distington, Whitehaven and Keswick. This was a national event and it raised £82 for the hospital funds. In 1935, the workmen's contributions were increased to 3d. The infirmary's jubilee year followed in 1936 and the town celebrated with a week of festivities. There were street parties and sports displays, and the week ended with a carnival and dance. The local Chamber of Trade raised the enormous sum of £20,000 to extend the X-ray department and the maternity wards.

It is interesting to note some of the costs of those days, and the hospital expenditure of 1937 includes:

100 yards of Sheeting at 1/8d per yard.
4 dozen Lavatory Towels at 5/3d per dozen.
6 dozen Tea Towels at 12 shillings per doz.
7 dozen Pillow Cases at 17/3d per doz.
12 yards Turkish Towelling at 1 shilling per yard.
21 yards White Damask at 7/11d per yard.
4 dozen Napkins at 18/6d per doz.

As with most supplies to the infirmary, these items would have been bought locally and made up by the infirmary sewing room, with voluntary help.

Then Along Came the Second World War

A blood bank was started and the beds then totalled forty-eight. Full employment and longer working hours had an adverse effect on the increased number of industrial accidents.

Workington was designated as a safe harbour, with increased shipping bringing ships crews from other nations, sometimes needing hospital treatment. The arrival of evacuees to the town, with the usual children's ailments, put extra pressure on the children's wards. The nurses worked longer hours in all departments, with the many gaps in nursing and treatment being filled by the local Red Cross detachment, whose help was most gratefully received.

On 5 July 1948, Workington became a member of the National Health Service, with succeeding improvements and beds increasing to a total of 132. In 2006, Workington Infirmary was closed and knocked down. A new hospital of only six beds now occupies the site of the former West Cumbria College on Park Lane. History has turned full circle in that, again, most patients are now taken to Whitehaven, (Hensingham) or Carlisle Hospitals.

From its birth in 1884, Workington Infirmary has fully met the needs of the local community, with the generosity and the financial backing of that same community.
Repeating the words of Abraham Lincoln, we can say of Workington Hospital that it was, most truthfully, 'of the People, by the People, and for the People'.

* * * * * * * * *

Postscript. Is it just chance, I wonder, that the west side of Wilson Ward overlooked the Harrington Road cemetery? Not a nice view for the patients!

Chapter 10

Who Will Put Out My Fire?

If your house caught fire in the old days, having the conflagration extinguished was a haphazard business. It is a curious fact, but local councils and authorities did not carry any responsibility for fires; indeed, they were not obliged to provide a fire service until the Act of 1938. If a householder expected to have the attention of a fire brigade in a case of emergency, he had to be insured by such as the Prudential or the Refuge Insurance Company or one of the many other companies. He also had to carry a 'Fire Mark' on his property (a brass plaque or company badge to help identify his property to the fire brigade and show that he was insured to have his fire put out by the local volunteers). Was this system efficient? Not really.

The best and most hilarious incident of how not to put out a fire actually came about in Cockermouth just after Christmas in 1876, as reported by 'Whiteoak' of the *West Cumberland Times*. A barn fire occurred in the night at Greysouthen, and whilst the villagers did their best with buckets:

Tom Weatherstone was sent to summon the Fire Brigade because his was the fastest horse in Greysouthen. He roused Mr Taylor the Fire Superintendent who roused Mr John Cook who alerted the members of the Fire Brigade. They had to be told by word of mouth because when Mr Taylor attempted to ring the alarm bell the rope broke at the second tug.

At the engine house they found the engine hidden under a pile of old tools and wheelbarrows which had to be shifted first. And then 'Heave, Heave', but the engine would not budge. One of the wheel bearings had seized up solid with rust and someone had to get an oil can to work it loose.

The firemen decided that if one wheel was rusted up the others also needed oiling so with commendable energy the firemen gave the engine a general service whilst someone else, discovering another urgent requirement went to rouse out the ostler at the Globe Hotel and borrow a couple of horses to haul the engine to Greysouthen. To make sure the horses would be alright and well treated the Globe ostler went along to drive them. Eventually the engine sped along Main Street to the cheers of those few people who had bothered to get up at that time in the morning.

At Brigham [...] a wheel flew off the engine and its crew were pitched head over heels into the ditch. A lynch pin had come off the axle so another was found and fitted, but a few hundred yards further down the road the wheel came off again.

Once at the farm [...] with three men on each handle of the manual pump, the Fire Brigade went into action. The men holding the nozzle of the hose waited in vain for the

The motorised fire engine.

water to appear, and then a shout from the now unemployed Greysouthen villagers told them where their water had gone. The hose had several holes in it and was spraying the crowd.

These crazy but true events apparently provoked the town into action, for a year later, not only were uniforms newly bought for the Volunteer Brigade but the local council took a greater part in organising a fire service.

The Workington Fire Brigade also had its Problems!

Workington Council provided a fire service of sorts from 1888, but its efficiency appeared to be lacking and it was dependent on funding. In 1889, the town council debated the question of fire cover for the town — or rather how to pay for it.

Mr McAleer wanted the committee to see if they could get the insurance companies to pay for it. 'After all,' he said, 'if a building did not burn down then these bodies could avoid paying out, especially since this saving had been at public expense.' He pointed out that in Manchester the insurance companies paid in £2,000 towards the cost of a fire service. Mr L. Ward proposed that a charge be made every time the engine was called out, to be levied on the person or organisation that needed the fire brigade. He wanted this charge to be at least £5, to pay for the wear and tear on the appliance. Councillor Wilson said that Workington's appliance was such a disgrace that nobody in their right mind would pay a 1d for its use. Before any such charge was discussed, he strongly advised the purchase of a modern fire engine.

J. Warwick, clerk to the council, informed the meeting that the insurance companies had stated that they would reduce fire insurance premiums in those areas that possessed an efficient fire service and that there was 'no point in pressing the companies for further payment'. Of course, he would state that, because not only was one of the local fire insurance companies the Cumberland and Westmorland (with offices on William Street), but one of its directors was also the clerk to the council!

Earlier in the meeting, Councillor Ward had come up with a novel idea that he claimed had worked successfully in Cleator Moor to get the insurance companies to pay up. He proposed that all buildings insured by them be allowed to burn down! No decision was reached and the council decided to discuss the matter at a later date.

This debate was in 1889, but it was not until 1913 that the town of Workington was provided with a regular fire service, with the purchase of a motorised fire engine and the building of a fire station on Harrington Road.

Smush

Incidentally, a regular sight on Workington's streets at one time was that of a chap trundling along on a rusty bicycle and carrying, draped over its frame, a sack of coal. Where had he been? He had been on the shore gathering Smush!

With some of Workington's coal seams going out to sea, it was regular for coal to be washed ashore, especially during stormy weather, providing a bonus in free fuel for the fire. All that was required was something to carry the sacks in or on! After a storm, it was a regular sight on Harrington and Salterbeck shores to see people shovelling up the coal to fill sacks to carry home draped over a bike, put in the boot of the car or, in the case of youngsters, carried using home-made 'flat wagons'.

Known as Smush, this shore coal burned very fiercely and was often the cause of chimney fires requiring the assistance of the fire brigade. Smush also became the subject of a folk song written and performed by a local singer, Edith G.

> From late September when the storms begin to blow,
> When it's wet and windy and you don't know where to go,
> Get on your bike, and bring some bags you're in for a big surprise.
> Coal is washed on the shore; you won't believe your eyes.
>
> Smush, Smush glorious Smush, put your bags on the bike and give it a push.
> Smush, Smush glorious Smush, put your bags on the bike and give it a push.
>
> [Spoken] Ista garn doon onto Wukinton shore for some shillies lad? Have got nowt for fire. Gud lad, take your clogs off and put them int back kitchen. You can borrow your dad's wellies. They smell a bit, they're int out house. If they're too big put your slippers inside.
>
> The coal is called the Smush and as far as the eye can see,
> Its six feet wide and two feet deep and absolutely free,
> Better a word of caution, pick out the stones,
> They may jump out and cause a fire and burn down your little home.

[Chorus] Smush, Smush glorious Smush, etc.

[Spoken] What … sum bodies let's air out of your tyres? Well pump em up agin and be on your way. Me old knees are gitten stiff wi cold.

And moving up to Salterbeck, wrap up in a sweater,
You could wear boots but Wellies are better,
The best time to go is when day is dawning,
When most of us are in bed like on a Sunday morning.

[Chorus] Smush, Smush glorious Smush, etc.

[Spoken] Crikey, how's a ganna git this lot yam afoor midneet, me tyres flat and me wheels sinking intut sand, me dad'll clout me lug. I'll have a thick ear int morning. His wellies are full of Solway; it'll take mare Smush than this lot to git them dry.

From late September when the storms begin to blow,
When it's wet and windy and you don't know where to go,
Get on your bike, and bring some bags, you're in for a big surprise.
Coal is washed on the shore; you won't believe your eyes.

Smush, Smush glorious Smush, put your bags on the bike and give it a push.
Smush, Smush glorious Smush, put your bags on the bike and give it a push.

Chapter 11

Some Curious Tales and the Inexplicable

As the cobwebs from this ancient town of Workington are being brushed away, more ghost stories are emerging, some attested to by letters from old soldiers.

One such letter came from a rifleman, a Mr R. H., from Wirral, Merseyside, who was billeted in Workington Hall — which we all suspect is haunted by 'Galloping Harry' — during the last war. To quote the letter:

The regiment arrived back in England after doing a spell in Gibraltar and we landed at Workington Hall while the regiment reorganised. The local people told us the Hall was haunted so we were put on our guard straight away. At this stage of war we could wear civilian shirts with tie and civilian shoes when we were off duty with our uniforms, and the beer was cheaper in those days, so if we were free Saturday night it was a good night out in the town. I had one or two pints too many and about two o'clock Sunday morning I wanted to go to the toilet which was a wooded building with the wash house at the back of the building. On going to bed that night I took my uniform off and jumped into bed which was a mattress on the floor with my white shirt and long-johns on and I said at two o'clock the toilet called so I put my civilian shoes on and made my way down the spiral stairs and out into the back of the building to the toilets, it was a full moon that night and on my return I just got to the bottom of the spiral stairs and started to take my shoes off because I might have tripped on the laces and at the same time the guard were coming out of the cookhouse which was on the ground floor at the front of the building at the end of a long passage. It was the guard's duty to see to the coal fire in the cookhouse and it was an excuse for a smoke.

I just arrived at the spiral stone stairs and I bent down to pick my shoes up as two guards came out of the cookhouse which was all lit up and one of the guards shouted halt who goes there and still being full of booze I thought if I dashed up the spiral stairs which I did they could not fire at me. I arrived in my room and jumped into bed, I heard the guard talking on the landing they came into the room and awoke the chap by the door and said has anybody come in here, and with him being sound asleep he said nobody has come in here. I was laying there in bed laughing to myself, I had made it. The next day it was all around the two guards had seen the ghost of Workington Hall and it was me; it just strengthened the sighting when the two guards had seen it, it had just disappeared. It was all around the pubs that Sunday night. I did not say anything because I did not know the consequences for not halting. I spent six years in the army during the war and travelled in quite a few places but always had the fondness memory

Was Galloping Harry dragged to his death down these stairs?

of Workington. I suppose it was the last place I was stationed here in England before going to India and demobbed in 1946. If you have any information about Workington Hall I would like to receive it. I have no website.
Yours sincerely
R. H.

But who was and is the ghost of Workington Hall?

Galloping Harry Curwen

The Curwen family can be traced back to before 1066. There are even family connections with the Scottish King Duncan, the one who was killed by Macbeth. They were feudal lords, landholders, knights, lords of Allerdale, and from their 'castle' at Workington, they defended the coastline of Cumberland during the Border Wars, in addition to being involved in national and international events throughout the history of England. Their history has produced a number of local heroes but the biggest 'cuckoo in the nest' must be Henry Curwen III, lord of the manor from 1673 to 1725. Traitor, exile and Jacobite rebel, who, because of his murder in 1725, has left Workington Hall with its ghost of Galloping Harry.

England, in those days, was a country of divided religious and political beliefs. Catholics were proscribed and persecuted by the Protestant Church and Cromwell's Puritan democracy. Catholics were not allowed to hold public office and they were expected to attend Anglican churches; the alternative was heavy fines or imprisonment. Catholics could not inherit from Protestants, and a number of Catholic widows married into protestant families in order to protect their property from Cromwellian edicts. Young Henry's grandmother, his grandfather's second wife, is believed to have been the widow of a certain Kit Wright, one of the 'Gunpowder Plotters' shot and killed at Holbeach House during the round up that followed the capture of Guy Fawkes. She gave her husband Thomas nine children, with Eldred, the eldest, being brought up in the old faith. In 1641, via a Covenant with Charles I (or rather his queen), Eldred and his protestant stepbrother, Thomas, re-entailed the Curwen properties to include the Catholic side of the family. (Re-entailing the property in another name was a legal ploy used by Royalists to protect their lands from Cromwell's rapacious Puritan parliament.) This ploy worked, but it had the effect of alienating the Curwens of Sellapark (part of Sellafield today) who came from the direct line of inheritance!

In 1673, twelve-year-old Henry Curwen III came into an inheritance that was arguably not his by right. Darcy Curwen of Sellapark did his best to have the re-entailment revoked but this royal Covenant was unbreakable. Being a Catholic, Henry did have Harrington church taken from him (after a forty-year argument!), but the authorities could not take the 'Anglican' Church of St Michael from him.

In 1688, James Stuart, the Catholic James II, was supplanted by William of Orange, who had been invited by parliament to invade and who thus became the next ruler of England. Galloping Harry ran guns into Workington for the use of James's Irish regiments at Carlisle. (Harry was sheriff at the time though, as a catholic, he should not have held that post.) There is a letter from Sir John Lowther to Daniel Fleming in 1686 in which he stated that 'Parliament being prorogued is a device to put Papist's into office'. After a raid on Workington, the arms were seized by Sir John Lowther, who took them for the use of William of Orange, who, as we know, took over the throne. Henry Curwen and other fellow Jacobites then fled the scene.

What Henry Curwen was up to over the next few years is, as yet, unknown, but it is presumed that he joined James II's court in France. During his absence, however, the Sellapark Curwens had him declared legally dead and took over the estates!

Henry returned to Workington in 1696 and proved that not only was he still alive but was also the rightful lord of Workington. He ousted Darcy Curwen and his family from Workington Hall. (Incidentally, the Sellapark Curwens were also his tenants!)

On his return from France, he also brought with him two Arab stallions that had been a gift from Louis XIV. (Had he also been a favourite of the King of France, who, as history tells us, financially supported James II's return to the English throne?)

The Curwen Barb and the Thoulouse Barb made him one of the top racehorse breeders in the country. Experts at Newmarket reckon that out of the top seventy or so racehorses in the early eighteenth century, fifteen of them came from the Curwen studs.

As a Catholic (according to the parliament of the day), he was not supposed to own any horses worth over £5. However, there he was breeding and selling bloodstock, with prices being quoted at £600 or 650g, increasing his private wealth as 'Galloper' Henry Curwen.

He also became a private banker. Jacobite families who were financially persecuted by the government turned to Galloper Curwen for help. He lent them monies using their mortgages as collateral, and if the loans were not repaid, he added the lands to those he already possessed.

The Jacobite rebellion of 1715, and especially the defeat at the battle of Preston, saw fifty Jacobites hanged, 400 jailed and many others fleeing the country. At this time, Henry Curwen, along with certain other Jacobites, was incarcerated in Carlisle Castle for having refused to swear allegiance to the Hanoverian Crown. On his release, Henry Curwen was not only sheltering Yorkshire fugitive Jacobites at Workington but was also suspected, by the local customs officer, of smuggling some of them to freedom in Ireland. Hence a beating he gave to the Riding Surveyor of His Majesty's Customs at Workington (a certain Joseph Miller, to whom he had to apologise by letter).

The 31 December 1720 saw the birth of one Charles Edward Louis John Casimir Silvester Severino Maria Stuart, who history knows as 'Bonny Prince Charlie'. The Jacobite movement was over the moon, because the future of the Stuart succession was now assured. Plots were devised to overthrow the Hanoverians and raise support for a return of the Stuart monarchy. Unfortunately, they sent their coded letters, plans, etc. by ordinary mail. Mails were stopped, letters opened and read and the result was a number of highly placed persons went to jail or the gallows. Was Galloper Curwen involved? The authorities thought so, because in 1721 he bitterly complained about his letters being stopped and opened by the postmaster at Cockermouth and also about being persecuted for being a Papist and being compelled to sell his precious horses, 'Lest they be seized as fines'.

The story of his death on 25 May 1725 was not recorded until 1899, when the following, according to J. F. Curwen of Heversham in his publication *The History of the Ancient House of Curwen*, happened:

> That, when Galloping Harry was nigh unto death a French Lady and her maid took the old man by the heels and dragged him down the stairs and left him to die in a lower room while they decamped with the family fortune and set sail for France. Fifty years later an old woman visited the Hall, to declare that;- she was the maid;- the ship had gone down off the Scilly Isles;- her Mistress drowned;- the fortune lost;- and after being saved she had spent a number of years in a Convent and returned to Workington to confess her part in the deed.

A curious enough tale, but is it true?

The documented facts are that Henry Curwen was sixty-four years of age and had never married to produce any issue, so, according to the terms of the document of 1641, the Curwen inheritance should have automatically reverted to the Sellapark stem. But the rebellious Galloping Harry had changed those terms!

In 1724, via his will and codicil, he passed all the estates the Curwens owned to his Jacobite family and his supporters in Yorkshire, denying the Sellapark family their rights to the inheritance. In his will he left all his personal fortune, his silver and 'Mortgages not otherwise accounted for' to a certain Lancashire widow and her daughter.

It would seem that Henry Curwen of Sellapark had secretly obtained a copy of Galloper's codicil recording his intentions, the same Henry Curwen of Sellapark stepping in quickly to seize the estates that should have been his by rights. (In less than a week, Galloping Harry was found dead. A rather curious fact indeed.)

After Galloper's death, and despite an argument to break the will, all that the Sellapark Curwens received was the single estate of Workington. Everything else, including the properties of the other twelve estates that the Curwens originally owned, was dispersed among Jacobite owners (including Galloping Henry's valuable racehorses). The Curwen dynasty had always been a rich one, but Galloping Harry Curwen all but destroyed it.

There is no public record of his death, just a brief note about his interment on 31 May 1725 in Workington's St Michael's parish church. The whereabouts of his grave is still a mystery.

Was he murdered by two French women as the story goes? I very much doubt it. His presumed haunting is the sound of his head going 'bump … bump … bump' down the stairs as the two women dragged him down!

> Yet still that awful noise is heard…
> That starts you from your Bed…
> That awful bumping down the stairs
> Of Henry's Dying Head.

Canon Curwen, rector of St Michael's and a son of the house, once told a tale to the local newspaper as to how he and his brothers had been out shooting and had then retired to the library after dinner with port and cigars. The two dogs, both of them spaniels, were lying in front of the fire when the room suddenly went chilly and the animals became upset, growling and whining. At this point, the door into the library opened of its own accord and the two dogs appeared to follow an invisible presence around the room. The presence then appeared to settle in an armchair (the dogs were staring at the empty chair), and after two or three minutes, it left the library closing the door behind itself. De Lancy, who was head of the house at that time, then turned to his brother, the Canon, and said, 'Looks like Henry is having a walk around again!' In telling the tale to the newspaper, Canon Curwen admitted that noises in the night and doors opening and closing on their own were quite a regular occurrence. The family took the invisible ghost for granted.

As the warden and guide at the hall in the past, I always watched the behaviour of any visitor's dogs. I have known dogs to become agitated and some even fought against entering the Peel Tower and undercroft where Henry was supposed to have died. For myself, I also encountered minor puzzling situations for which I was unable to find any logical explanations.

Galloping Harry Curwen, the penultimate of the bloodline, was quite a character. Is it so curious that his psychic presence is possibly still around Workington Hall?

The Lady in Grey

An undated letter about a sighting of a strange figure could point to one of the two murder mysteries that occurred in 1881 and 1932.

To quote the letter:

> My late wife, on occasions when the supernatural was being discussed, always related this incident.

She, in the company of her aunt and sister were returning from Northside shore after spending the afternoon there.

At the time my wife was in her early teens with the other two girls slightly younger. (Late 1920s or early 1930s; - early summer). It was dusk when they were approaching Calva House from the town side, when in front of them they became aware of a figure dressed in a long gown in front of them. As she approached the gate of the house she disappeared.

My wife, of no great judge of distance or directions, gave me the distance of 30 yards plus or minus 5 yards. Her retelling always kept the same.

H. L.

Now, Calva House is not all that far from what was known as the Black Pad. A footpath that ran alongside the railway at northside and that always had a bad reputation.

In December 1881, Lucy Sands disappeared, with her broken body being found the following March under a pile of stones on the road to Northside. Despite the police investigation and inquiries, the verdict was 'wilful murder against person or person's unknown'. She had last been seen in the vicinity of the Black Pad.

On 6 January 1932, Nancy Patterson's body was washed ashore at Silloth. The medical evidence showed that she had been dead before she entered the water. Again, she was last seen alive on the Black Pad on the evening of 3 January walking towards Navvies Bridge. After a comprehensive inquiry the verdict was 'murder against person or persons unknown'.

Was this mysterious figure, seen by the three young girls, the spirit of one of those two unfortunate girls?

The Steam Packet Inn on the Quayside

Over the last ten years, the proprietors of this historical pub, sited at the far end of the quayside, have experienced quite a number of supernatural occurrences.

About four or five years ago, P., whilst working in the kitchen alone, received a slap or smack across his face, which, apart from being sore, left him with a red mark for a couple of days. This apparently happened more than once. At other times around this period, the security alarms sounded whilst the doors were locked and undisturbed.

Several times M. has seen a man's face at the window but, on immediately going out, there has been no one there. The man appears to be wearing an old-style seaman's cap (Dutch?) The windows that overlook the quayside were replaced in 1925. One of the regulars claimed to have seen a bearded man at the bar smoking a pint and wearing a Dutch cap, whilst others of the regulars have felt someone behind them. On one occasion, a figure was seen walking through the wall at the gable end of the pub. Now, in the very early 1800s, the site consisted of three houses, with bedrooms reached by spiral staircases, whilst the gable wall has had a doorway blocked off. (An interior door or exterior door from the previous houses?)

Reported deaths in the locality include that of a man who dropped dead as he was entering through the side door (now blocked off) and also, in the early 1900s, a Dutchman who died of a heart attack whilst at the bar of the Steam Packet Inn.

About four years ago, a friend offered to pull a pint for M., who was in the kitchen at the time. He went to wash his hands first. When the friend came out of the toilet, it was

to find that a number of pints had been pulled off. But M. had never left the kitchen and there wasn't anyone else in the bar to serve them (so who had pulled the pints?).

Now, the door into the office had a broken bolt. On one occasion, whilst M. was sat at his desk, the bolt shot out about five feet. Not only did the bolt hit drinkers in the bar but the event was also witnessed by a number of them. Again, small objects disappeared only to later return to the place they disappeared from.

Similar to other haunted sites, odd activities do take place at the Steam Packet Inn whenever there are any alterations done. (Spirits do not appear to like changes taking place.)

A Spirit Named Elsie

It seems that a rather cheeky ghost was apparently that of a previous occupant named Elsie, who, for a time, haunted number 110 Stainburn Road. Elsie, it seems, was a great one for switching lights on and off, and opening and closing doors. Sometimes, the smell of pipe tobacco also wafted through the house.

The door of one of the bedrooms did not close properly because of an uneven floor. A friend of the household at the time actually found herself locked in and after calling her hosts up on the phone as to how she could open the door, the house owner shouted down the phone to 'Elsie' and the door unlocked itself.

'Elsie' also used to lock strangers to the house in the toilet, and on one occasion when the old lady who had been locked in was deaf, they had to pass the key under the door to allow her to open the door. This passing of the key under the door was a regular thing to do whenever 'Elsie' locked visitors in the toilet!

The Curious Case of the Little Old Lady

The occasion was a Christmas party at Douglas House, Belle Isle Place, Workington, sometime during the 1950s.

This old house — built sometime in the eighteenth century and since occupied by large families — was great for children's parties, with most of the games taking place in the big front room on the first floor and stairs. The following story was recalled by T. H., one of the former owners of Douglas House.

> The house had been much altered and the 1st floor kitchen was in what was the dressing room to the main bedroom, with a bench seat fitted in the alcove between the chimney breast and the staircase wall with the dining table set in front of it. The party was in full swing when I entered the kitchen to check on the eats and found the mother of some of the visiting children seated on the bench seat with our Alsatian dog, Silver beside her. Our dog was never known to have jumped on any furniture and was not allowed to do so. Our friend was aware of this and said, 'It's all right, there's a little old lady sitting with us and stroking Silver. She is so pleased with the party because this has always been a happy house.'
>
> (What could I say to that, because I did not see any little old lady on the bench with the dog or our friend, nor were there any old ladies amongst the guests? But our friend

was a sane family person so I carried on as normal.) The dog Silver never again jumped on the furniture to our knowledge.

Another recounting of the spirit of Douglas House was recalled by Mrs H. It seems that their son and daughter, when small, spent a wet afternoon in one of the rooms upstairs. When called down for tea, they declared that they had been with a little old lady.

Years later, when their daughter was in her teens, she spent a few hours upstairs one afternoon and later, when she came downstairs, stated that she had been with a nice old lady. Just who is this little old lady whose spirit does not seem to want to leave this apparently happy house? No one knows. Presumably she is a former occupant?

A Voice from Beyond the Grave?

Long before shops had regular newspaper deliveries and late opening hours and there was a newspaper kiosk in the town, it was down to the paper lads to sell as many newspapers as they could. Most would go around the streets of Workington calling out, 'Evening Star, Evening Star' and selling to the householders.

One particular night in darkest winter, when one young lad was walking along Harrington Road chanting his wares and passing by the cemetery, from over the cemetery wall came a voice, 'Yis lad arl have yan'.

Fearing the worst the young lad set off 'L' for leather up the road and only stopped for breath at Moss Bay! Hopefully it was the curator and not one of the cemetery inhabitants! (A tale recounted by I. F.'s father, who apparently heard it from the newspaper lad himself.)

The Ghosts of Udale Street?

It is a curious circumstance, but it appears that what was once Udale Street, at the foot of Ramsey Brow, has had a number of ghosts. Today, the area is a car park with Marks & Spencer, Butterflies Café and a very small number of cottages on the western side. On the eastern side of Bridge Street and facing Marks & Spencer across the car park is the new courthouse. This has a curious reputation of being haunted. It would seem that during alterations to the West Allerdale Courthouse, which was erected on the site of the Hall Stables in April 1966, what can only be described as poltergeist activity took place.

The *Times & Star* newspaper reported the following:

> Messages were removed from notice boards; clerks followed other 'persons' into offices only to find nobody there and a computer mascot, (a woolly sheep), flew across the room without any human aid. Electronic faults occurred where there was nothing technically wrong to be found, and the supervisor admitted that odd things did happen whenever any alterations to the courthouse took place.

As a sequel to the curiosities of the courthouse mystery, The *Times & Star* reported on a previous haunting that had taken place in October 1921 in a house on Udale Street just across from the courthouse.

It was a letter that had been discovered and written by a lady called Ethel, a former resident of Udale Street.

'Do you know Herbert?' Ethel wrote, 'That ghost batters and bangs like mad all night now and when Florrie went down to get some cough sweets, she said it touched her and threw whatever it laid its hands on. The Revd Jackson says that he is trying to get us another house away from this terrible street.' (The house no longer exists, the site having been taken over by a new Marks and Spencer store on Udale Street.)

A very curious tale this, because there is a late-nineteenth-century story about a Belgian seaman who went by the name of Johnny Pom-Pom and lived on Udale Street. (In the nineteenth century the uniform of French and Belgian sailors included a 'Bonnet' that was decorated with a 'Pom-Pom'.) Whilst he was away at sea, his wife, it seems, took a lover, and when he returned, he caught them together. In a drunken rage, he murdered his wife's lover with an axe.

Another tale about this street concerns a travelling preacher who was accompanied by a young man, with the pair of them lodging for a while on Udale Street during the late 1800s. After they had left the town, the people who drew their water from Friars' Well (the fresh water spring that at one time supplied the town with drinking water) found the water to be tainted and foul tasting. When they checked the well, the workmen found the rotting corpse of the young man. Yet another mystery to add to the curiosities of Workington.

The Guard Street Smoker

Curiously enough, the ghosts of Workington are not only seen and heard but they can be detected by odour.

Croft House, or number 68 Guard Street, was once the home of Dr Washington, a retired geography teacher who taught at Workington Grammer School. Part of the house was late 1600s, and it was situated next to a 'Miss Kittas' school (a penny school?) and the two properties had been joined by a family marriage.

Over twenty years ago, a new family took over the property, and until ten years ago, they were aware of the smell of pipe tobacco pervading the house, but only downstairs. There was never any feeling of unease. The daughter of the family used to practise on the piano that had been purchased with the house and she used to comment on the smell when she was practising.

Perhaps, when the spirit of the old gentleman heard the gentle tones of the instrument, he stopped and listened.

The Tale of Thompson's Thumb

> Joseph Thompson may here be found,
> He would not lie in consecrated ground,
> Died May 13th when he was alive.

This inscription can be found on a gravestone that stands, not in a cemetery, but by the side of Scaw Road at High Harrington, near Workington. It is an oft-told tale and, whilst it seems difficult to believe, it is quite true.

Back in 1744, Joseph Thompson, a local farmer, had a small accident to his right hand, which left him with a festering thumb. It was painful, swollen to a large size and gave off a very nasty smell (Yeugh). It was so bad that even his friends avoided him! What was wrong with his thumb has never been medically stated. Did anybody know for that matter? (The fact that he began to waste away suggests that possibly he was gangrenous?)

Farmers in those far-off days were also their own doctors as far as animals were concerned and Joseph tried a number of folklore remedies. Poultices with such ingredients as 'An Carrots, an Puppies? an Toadstools, an Sneals, an roasted beath Hagwurms an Eels', not to mention other unmentionable substances, but it was all to no avail.

When the local vicar advised him to put his affairs in order, only then did he see a doctor. This was an expensive visit and the medical opinion was 'CHOP IT OFF', which on being done, saw Joseph go home a poorer but happy man. With his thumb in his pocket!

Being a religious man and a strong Bible student, Joseph decided he would like to inter the thumb in the churchyard, where he would eventually be united with it when his time came. But this idea did not meet favour with the vicar and his clerk, resulting in an unholy, or was it holy, argument.

So Joseph then persuaded his wife to visit the graveyard after dark and secretly bury the thumb. But he was still not cured. He ached all over, even suffering a pain where the thumb had been!

With the vicar's argument still ringing in his ears, Joseph withdrew from the church and persuaded his wife to go and exhume the thumb in order to bring it home to be reburied on his own land. Once this was done the pain stopped. But because of the row with the church, he decided to be interred with his thumb on his own land, refusing to be buried in consecrated ground.

When he died shortly afterwards, in May 1745, he was interred in the field adjacent to 'Scaw Lonnin', and when this path was surfaced to become Scaw Road, his gravestone was removed to the side of the road where it still stands to this day. On nineteenth-century ordnance maps, the field is named as 'Gravestone Field'.

In 1868, Joseph Thompson's thumb became quite famous, when in his book, *The Folk Speech of Cumberland*, Alexander Craig Gibson, the dialect scholar and writer, devoted five pages to a dialect poem on the subject of Joseph Thompson's swollen digit. A tribute to a curious tombstone, found in a strange place, with an even stranger story.

Chapter 12

The Story of Friars Well

From *The Inductive History of Workington* by a Sergeant C. Hall

This weird and strange story appeared in one of the local newspapers of the mid-nineteenth century. (Date and newspaper unfortunately not known.) It appears to be of sixteenth- or seventeenth-century origin. With the legend of Friars Well, is it a story based on an early murder?

Friars Well has been the source of Workington's fresh water supply for centuries and is sited facing west at the foot of the hill on which stands Workington Hall. Today, its red-brick façade faces the police station. The story goes like this:

> It seems that at one time there dwelt on the margins of the River Derwent in a rude hut a very unsociable character who went by the name of Slapey Buttock and one summers morning he was awakened from a few hours sleep by heavy knocking outside of the door of his hut, and very much greater swearing from the person on the inside, and at last in sheer desperation he arose and opened the door.
>
> 'Humph', grunted Mr Slapey Buttock. As he got out of his apology for a bed, 'just wait a few minutes, my friend and I will see if your head will stand as much knocking as that door', and he grinned till his face assumed the shape of an India rubber head that is pulled out sideways.
>
> But when Slapey opened the door and discovered that his importunate visitor was a Friar, he altered his resolution somewhat and instead of making a battering ram of his head, he gruffly asked him what he might want.
>
> 'Want' answered the Friar, 'why I want rest and something to eat and drink'.
>
> 'So do I' said Slapey, 'but I don't know where I'm to get them.' 'Well there are surely places in the town where food and drink may be procured for money. Take these and get what will suffice', and so saying the friar threw towards Slapey a couple of gold pieces which he took from a bag of the same. The sight of so much gold roused the cupidity of Mr Slapey Buttock and he at once resolved a course of action while procuring the provisions and having decided on his course of action, he had no sooner returned from his errand than he knocked the worthy Friar on the head with a lump of iron; and after securing the bag of gold, threw the body into Friar's Well.
>
> He had scarcely returned from this funeral and was busy counting his ill-gotten wealth when he was arrested for uttering false coin; and to his astonishment he discovered that every coin in the bag was counterfeit as well as the two he had taken

Murder at the Friars Well.

to buy food with. He was so disgusted at having overreached himself, that; as soon as an opportunity presented itself he cut his throat with a piece of old hoop iron. His body was interred at Cross Hill.

It should be stated that, previous to the murder of the friar, the water of the well into which his body was thrown was anything but pure, and the astonishment of the natives may be imagined when they discovered that the water had suddenly become pure and sweet, with a taste rather like port wine.

The cause of the change was one day discovered when a labouring man fished up the bloated body of the murdered friar; from that day to the present time the well has been known as Friars Well and the water noted for its purity.

(A weird tale indeed, but some of the sentiments expressed in the story are typical of sixteenth- and seventeenth-century folklore; or could it possibly be a recollection of a murder that took place in the sixteenth century?)

Chapter 13

Taxes and Taxation

Everyone suffers the burden of taxation and so it was and still is with the people of Workington. But have you ever considered the strangeness of some of the taxes that existed in the past and government's weird ideas in promoting some of them?

In the story of Friars Well, you have a member of the church spending counterfeit money, weird in itself, but not all that strange regarding the times in which they then lived. Cash at one time consisted of gold and silver coins of exact weights according to their values. A widespread crime of those days was that of 'coin clipping'. Snip pieces off the gold and silver coins and mix it with other metals (usually lead) to recreate false coinage. This not only, of course, had the effect of reducing the value of the coins themselves but also ensured the circulation of large numbers of counterfeit coins. Bankers and merchants regularly weighed coins to ensure that they were of the right value. In a number of old fiscal records you can find the curious phrase 'True Coin of the Realm', monies that were correct in both value and weight of the gold or silver. The crimes of 'coin clipping' and the counterfeiting of money were so serious as to be considered a treasonable offence, with the death penalty as punishment.

In 1747, the government brought out a tax on windows, which replaced the earlier hearth tax. You paid 6*d* a window on top of a basic 2*s*. Over ten windows and they cost 6*d* each but over fifteen windows, 9*d* each. A tax on receiving daylight, you might say, but what was stranger still was the fact that this tax was to 'Help meet the reminting of the damaged coin of the Realm'. (Counterfeiters robbed the country of its revenue, so the Tory government of the day brought out a special tax to make up for the revenue losses caused by the criminals — strange!) The tax was not abolished until 1851.

There were many other curious taxes in Workington in the old days. To prove that time flies, people were taxed on the possession of a clock or watch (this is true, but the tax only lasted for a year)! A tax was levied from 1796 to 1882 on the ownership of a dog (the dog licence was a later imposition). A tax was imposed on the employment of servants, first on female servants and later on male servants too.

Not only was duty payable on wigs, but from 1795 to 1798, it was required that people using hair powder (in some cases ordinary flour) should pay duty and obtain a licence (another very strange tax!) A tax known as House Duty was levied on inhabited houses from 1851 to 1924. This particular tax replaced the tax on windows!

Income Tax was first introduced in 1799 to pay for the war against Napoleon Bonaparte. At 2*s* in the pound, levied on the rich, it only lasted two years. It was abolished in 1802 and then revived in 1803, and in all its variations, it is still reviled

The Butter Market on the Market Square in the nineteenth-century.

and still, regrettably, with us. A tax was levied on christenings, marriages and burials recorded in parish registers, which resulted in a fall in entries. (Although repealed in 1794, it means that some families will find their ancestors missing from the records.) Farmers were taxed on the number of horses they had, and if you were lucky enough to own any silver plate you were taxed on that.

Except for the window tax, the majority of these strange and sometimes curious taxes were the Tory government's answer to the escalating costs of the Napoleonic Wars in Spain; these, sometimes high, taxes created poverty amongst the working classes.

Until arable and cattle farmers learned new methods in the eighteenth century, the majority of the working class lived at near starvation level. Their staple foods were vegetables, cheese, meat (mainly pork) and cereals (mainly oats and barley).

To alleviate the poverty in Workington, however, John Christian Curwen, the then lord of the manor, brought in measures that reduced the production costs of his farms in order to sell his produce to the local populace at much lower prices.

John Christian Curwen was thought mad when he installed potato-mashing machines at Schoose Farm. For farmers hay was expensive, so J. C. C. fed his many horses on mashed potatoes, carrots and just a little hay. Not only did this diet keep his horses well nourished, but he was also able to release several acres from the growing of hay to

that of growing vegetables, which went to feed the local population. He also introduced 'tatie picking weeks', where locals were invited to harvest and bag potatoes by hand. For their labours, they were rewarded with a bag of potatoes or vegetables, or even an amount of cash.

The tradition with beef was to cull the cattle in winter and preserve the meat by salting it. John Christian Curwen stall-fed his dairy cattle through winter, feeding them with 'cattle cake' — yet another of his odd ideas! However, because of the 'funny' taste of the milk, some locals reckoned that he was trying to poison them. Undeterred, he tried another cake 'recipe' which, this time, produced normal-tasting milk. His milk production and sales rose, with the population of Workington enjoying milk throughout the year at low prices, which also brought about a general improvement in the health of the local population.

Thanks to these radical schemes and odd ideas, poverty was not a major issue in Workington in the latter part of the eighteenth century (unlike the rest of the country). A large number of John Christian Curwen's radical and curious ideas, especially his agricultural methods and, of course, his sickness benefit scheme, are taken for granted today.

How Does One Eat a Boiled Egg?

Now, you might think that those taxes produced by the parliament of the time were weird, but consider this strange circumstance.

Jonathan Swift's *Gulliver's Travels* was written as a satire on the times. In the story concerning Lilliput, the argument that started the war between the Lilliputians and the empire of Blefuscu was because of which end they should break their boiled eggs. But where did Jonathan Swift get this 'fiction' from?

Believe it or not the parliament of that time had made it an 'offence in law', with the punishment of a fine, to break your breakfast or tea-time egg at the pointed end (incidentally, this law has just come off the statute books). How Workington fared with this particular piece of parliamentary legislation I do not know, and, clearly, it would have been a very difficult law to police. (Instead of checking on criminals, were the local police expected to investigate as to how people ate their breakfast?)

The Lowther Arms Inn on Portland Street.

Chapter 14

Oddities from the Upper Town

Overlooking the nineteenth-century town of Workington is the so-called Upper Town. It was, of course, the original town of Workington, a small market town surrounding the castle-like home of the Curwen family, lords of the manor. A sixteenth-century description of the town gives thirty houses to the south and west of Workington Hall. The Market Charter was granted by Elizabeth I in 1573, with the market being held on Cross Hill. The twelfth-century Church of St Michael did not get its Rights of Interment until the fifteenth century, with all burials prior to that taking place at Camerton church, which dates back as far as the tenth century. The dead, of course, being brought in from the outlying villages along Corpse Road. At Cross Hill, there was a chapel of ease (re-built in the reign of Richard II), where the dead were rested. A homily was read over the corpse and then the procession would wind its way along the Corpse Road, now Park End Road, and through the Mill Fields to Camerton for burial. Built into one of the houses on Cross Hill can be seen stone crosses dated 1703, possibly from this early chapel or, perhaps, denoting the erection of houses on the site of this former chapel of ease.

Park End Road is supposedly haunted by a grey lady or a ghostly nun. There was a convent of Poor Clares sited halfway along the road at one time. Could these ladies be a haunting from the convent or is it a folk memory of the days when this road was called, and used as, Corpse Road?

The market was eventually moved to the Upper Market Square. Originally known as the Butter Market, in the centre of the square stood a circle of stone slabs within a cupola, from which farmers' wives sold their dairy produce. (A curious feature of farm life in bygone days was that the production of butter and cheese, etc. was the sole province of the farmers' wives, who sold these surplus products to create their own 'personal' pocket money.) Sometime before 1914, this open market was re-sited at Hagg Hill in the lower nineteenth-century town. Typical of old market towns, the Butter Market had its inns, and at one time, there were no less than eight in and around the square.

Running off the square is Curwen Street and to the right of this is Portland Street, which leads to Portland Square, a conservation area with Georgian cottages, cobblestones and trees, or, as some of the locals referred to it, 'Knob Hill' (it was in Portland Square, of course, that you got the residences of the upper classes and the commercial classes). It was, however, actually built on a tannery!

On Portland Street today is the Town House Restaurant. Built in 1763, it was known as the Moot Hall and then became the Curwen Workhouse, after which it was the

Portland Square showing the monument to Dr Peat.

Lowther Arms Inn. When they altered the workhouse to create the pub, the workmen found the body of a very young child bricked up in the wall (yet another unexplained curiosity for the town of Workington).

The first houses appeared in the square during the 1730s, after William Salkeld purchased the land ('All that freehold Tan Yard or Parcel of Ground with its outhouses, sheds, and outbuildings situated in Moot Hall Croft in Workington together with the use of the well water near thereto') in 1728 for £385. He then purchased more land from John Christian Curwen, on the Fox Lane side of the field, the site of the former Green Dragon Hotel. After his death in 1887, his son, Henry Salkeld, bought the land at the corner of Elizabeth Street and Fox Lane, and this section of the tan yard then became the site of the Green Dragon Hotel and Posting House (today the Portland Hotel). Portland Square was named for the Duke of Portland, who was one of John Christian Curwen's political allies in the fiercely fought elections of the late eighteenth century.

From here, we will let a Mr Philip Milburn take up the brief story of the square as he gave it in an address to the Workington Rotarians on 1 December 1937. His family had been connected with the square for upwards of 172 years, at a time when the population of Workington was little more than 5,000 persons. He mentioned that elections were held at the Green Dragon when the Curwens and the Lowthers were fighting for power in West Cumberland — the Lowthers fighting dirty! In those days, the working man did not have the right to vote. However, Lord Lowther twice bribed his miners

from Whitehaven to cast their votes (so-called Mushroom Votes). After parliamentary arguments, Curwen won his seat in the house (twice) and then he brought in the Act which today forbids any such illegal practices.

In the southern corner of the square stand the Assembly Rooms, which were built and financed by John Christian Curwen as a 'national school'. Over the years, it has seen use as an army headquarters and a civic hall, and it has played host to some of the top entertainers of the Victorian era, including Dame Nelly Melba. The houses facing this on the opposite side of the square boast an unusual feature: a wall-mounted sundial that, curiously enough, is sited in a position that, being overshadowed by the buildings, sees very little sun!

There were two other inns in the square in addition to the Green Dragon. One was the Wheat Sheaf at the corner of Cavendish Street (originally known as John Street). The other inn was the Coach and Horses, kept for many years by the McCade family, whose grandfather drove the Workington to Carlisle stagecoach. During the latter years of the nineteenth century, a Mr W. Smith, landlord of the Lowther Arms on Portland Street, ran a twice-weekly coach service between Workington and Moss Bay on market days (Workington's first public passenger service?). John, his son, drove the coach.

No. 11 Portland Square was the household of Dr Peat, the local physician and chief medical officer, whose memorial (because of his devotion to his patients during the cholera epidemics) stands in the centre of the square itself.

Branching off from Portland Square is Cavendish Street, which saw the residence of a very old-fashioned doctor! This was Dr Dickinson. His curious remedy for cuts and scratches was to place spiders' webs on the wound until it healed. It is known today, of course, that spiders' webs do contain a substance that acts as a coagulant. It was Dr Dickinson's practice to keep small children quiet in his surgery by giving them a stick of liquorice or other sweet to suck. He also believed that no house could be healthy unless it had a few cobwebs in some corners! Let's face it: flies spread disease and spiders kill flies.

Lucy Sands, the seventeen-year-old who failed to return home in December 1881 and whose body was found on 1 March 1882, lived at 2 Christian Street on the corner of Portland Square.

Workington has yet another phantom of the night in this upper part of town. Once described as 'an old-fashioned square in an old-fashioned town' the square does, in fact, have an old-fashioned ghost. Beware the phantom hearse, for to see a hearse or to hear the clip-clop of the horses' hooves in the square during the night is an omen of death! Curiously enough, this is, apparently, true. The hearse was seen and a death occurred subsequently. How do we know that? Because a certain undertaker kept his hearse and his horses in the stable of the Green Dragon at one time!

It's a Riot

In 1813, John Christian Curwen had toured Ireland observing for parliament in detail the poverty of the people and the failure of the agricultural system there. In letter number 47, September 1813, he stated that 'it was impossible to survey the dirty and dilapidated buildings, without sympathizing in the general suffering. To behold a large community bowed down in hopeless indigence, cannot fail to inspire feelings of a most

painful nature, in those who are but transitory visitors!' So he welcomed the Irish into Workington, where they found employment in his pits and on his farms. To cater for their spiritual needs, he also provided a mission and a priest.

Not all went well initially, for they were 'visited' by a militant 'Orangeman' from Birmingham named Kelly, who harassed and created trouble for the peaceful Irish until he was murdered on Easter Sunday in 1814. He was kicked to death on Elizabeth Street in the upper town, with 'five men seen running away'! It is a rather curious fact that when the Workington Town Council tried to return Kelly's body to his home town of Birmingham for interment, the council there refused to take it. However, after an argument, they reluctantly took it.

In the following September, a rabble, led by an ex-drill sergeant by the name of Pearson, another Orangeman, broke into the houses of the Irish, dragging out the occupants and beating them up. One old man died from his injuries. The old squire, John Christian Curwen, was to be seen on horseback, with his stick in one hand and a copy of The Riot Act in the other, riding through the rabble and commanding those 'who loved law and order to retire to their homes'. The Irish obeyed and the evening ended with a few skirmishes. Early the following morning, however, the Fife and Drum Band of the Orange Order paraded through the streets beating to arms. They were soon joined by miners, led by two of the Orange leaders, with drawn swords; again, the peaceful Irish were attacked! Doors were battered down and the occupants were forced to defend themselves with pans, pokers and stools. This second riot was soon over, for Curwen and his fellow magistrates had called in the militia, who soon dispersed the mob.

Miners took to the fields and outlying countryside to escape from the dragoons, because any man they arrested was immediately impressed into the army. A number of Workingtonians (reluctantly) found themselves in the ranks at the Battle of Waterloo a year later. Reported in the *Cumberland Paquet*, the local newspaper at the time, was the following:

> Tuesday Sept 13th 1814.
> The detachment of the Whitehaven Militia which had been called upon to assist the civil power at Workington returned on Wednesday. By their firm but temperate conduct they were at once to insure the tranquillity of that town; - and the favourable opinion of its inhabitants. Since our last; have been committed to Carlisle Goal, charged with being concerned in the riot; Joseph Bowness, Joseph Pearson. Joseph Allinson and William Bell. Warrants are out against eight others and rewards for apprehending them.

Chapter 15

The Marsh and Quay

This maritime area of Workington, being situated along the shore and around the docks and harbour, has developed throughout history as a separate community within the township of Workington. Back in the sixteenth century, it consisted of a group of fishermen's cottages on the fringes of a Marsh. (It was here, of course, that the refugee Queen of Scots first set foot on English soil, and on the quayside today stands a memorial to this unfortunate lady.)

The growth of the area started in the eighteenth century with the erection of cottages for the miners at the Chapel Bank Colliery, and the developing docks and harbour brought even more inhabitants. Originally a marsh, the district was reclaimed from the sea by filling in the wetlands with ships' ballast, creating the land on which the expanding railway yards and loco sheds were eventually to be sited.

* * * * * * * * *

In the late eighteenth century, the Napoleonic wars and the government's propensity for taxation and even higher excise duties on imported goods brought about an era of poverty, a situation that was alleviated by smuggling. Known as 'Free Traders', these 'gentlemen of the night' clandestinely brought goods into the country duty free! There was a curious import system known as Claw Back, whereby an importer of goods bringing them into an English port paid his excise duty but on exporting the self-same goods abroad received his money back! It was the practice in these northern parts for a merchant to pay his dues (without actually unloading the goods) and then export them to The Isle of Man (getting his money back, of course).

The Isle of Man was duty free, so these same goods were then returned to English shores by Manx merchants with the help of the free traders (smugglers), who, of course, sold the goods duty free — smuggling as a business! Certain importers even traded direct with Manx smugglers! Tea, for instance, at one time carried a duty of 400 per cent, and it has been estimated that out of all the tea drunk at that time only 25 per cent of it was duty paid; the rest had been smuggled in!

A traveller staying overnight at the Golden Lion in Whitehaven in 1813 paid £4 0s 6d for his wines and spirits (how many glasses he consumed is not known). In the same year, a curate from a church on the English side of the border had purchased a gallon keg of brandy from a Scottish smuggler for 3s 6d plus a 'carriage' charge. (In those days there was a very large difference in costing between smuggled, 'duty-free' goods and duty-paid goods.)

Workington main station divided the marsh from the quay.

Were the inhabitants of the marsh and quay involved in smuggling in those days? Did they defy the law and the Customs and Excise officers? Of course, they were and did!

Regular visitors to the harbour were Manx fishing vessels selling their catches of cod and herring, etc. (hidden amongst which was to be found contraband). Workington exported coal to Ireland, and the stocks of coal lying in the staithes at the harbour side were occasionally used to hide contraband but only found the once by searching Customs officers.

Reported in the paper in 1810 was the curious incident of a Customs 'searcher' falling down dead whilst searching a vessel for contraband. He apparently died 'From the over consumption of Brandy' — a literal slant on the term 'dead drunk'! Had the smugglers been treating him to drinks or had he been helping himself to the cargo? Another newspaper report was that of a Scottish smuggler being killed by a musket on board his ship.

Customs officers boarded a vessel in Harrington Harbour and recovered a fair amount of contraband (six pony loads). As they made their way along the Lowca Road to the warehouses in Whitehaven, they were attacked by smugglers and a large number of irate

locals. The resulting skirmish saw the contraband re-taken by the locals, the Customs officers returning to Whitehaven empty handed and nursing broken bones and heads!

* * * * * * * * * *

The Marsh and Quay saw even more expansion in the nineteenth century with the establishment of the shipbuilding industry and its attendant manufactories and foundries connected to the steel-making industry. By the early twentieth, century the Marsh and Quay was a thriving and busy offshoot of industrial Workington. As a community, it boasted about 300 houses on both sides of the railway, and to get from one part of the community to the other was via a level crossing across the railway.

In 1886, the opening of a new railway station, built by the London & North West Railway Company, was announced. With this new station came goods yards, locomotive sheds and a viaduct to span the railway lines. A curious announcement on 6 November stated that 'The various Waiting Rooms, Offices and Platforms were completed and that there would be some changes made in the checking of tickets and that the platforms would be kept "private" for passengers only or those who purchase "Penny Platform Tickets".'

'Touting' by busmen and newsboys is no longer permitted. (Perhaps the suddenness with which the gas was turned down after the departure of a train, before the passengers have had time to get away, was a little annoying?) The station was formally opened on Sunday 7 November 1886. This, of course, was Low Station.

The community had its own school on Lawrence Street, a Mission House and, of course, its public houses — like all docklands, it had its fair share of those; indeed, there were eight pubs in three streets! The houses were of the typical Victorian terraced style, with some possessing three storeys. There were narrow back alleys, whilst some of the smaller eighteenth-century miners' cottages not only shared a washhouse but an outside toilet as well.

The washhouses were equipped with large boilers for the washing of bed linen, etc. and during the depression of the early twentieth century, these boilers were used to make soup and broth for the needy, with all the households contributing vegetables, barley, meat — whatever they could spare. One old lady who lived on Stanley Street kept pigs in her backyard, and regularly provided bones and meat. When times were hard, in addition to the prevailing community spirit, there was always the sea and land to provide for the inhabitants of the Marsh and Quay.

In the 1890s, beef had been 7d per pound, potatoes were three ½d to 2½d per stone, milk was 2d per quart, buttermilk was for the asking, coal was 1d a Rueful or 6s for 12 cwts and rents 1s to 2s per week. Not only could fish be bought cheaply but salmon from the River Derwent was freely available in the season. By the time of the recession, prices had risen very little. (It is a curious fact that in many northern towns, and especially Workington, the cost of living has always been a lot lower than the rest of the country.)

Some of the 'wet fish' shops were 'trawler owned' (this meant that the shop owner also had his own boat, selling his catches through his shop at much lesser prices than the commercial retailers). Palmers of Washington Street and T. F. Percival of Fisher Street were two such 'trawler-owned' shops. Palmer was also a dealer in game and poultry, who bought locally and purchased rabbits for resale from farmers who had shot or

trapped them on their lands. Another local curiosity was that workmen often had their own boats, sometimes just rowing boats or small motorised vessels, and spending their spare time at sea, they would sell cod, mackerel or strings of plaice for just a few pence to the locals.

Spring is the time when salmon swim upstream to lay their eggs. It was also the time when some of them, making for the estuary of the River Derwent, found themselves trapped in the open dock, the dock workers and their cronies going 'Clicken' in order to catch them. (Just what is meant by this curious term I do not know, but as the spearing of salmon and trout was a traditional way of catching fish, I can only presume that that was what the locals were allowed to do.) This annual practice ceased when, in 1927, they erected gates on the new Prince of Wales Dock.

Inland, on the farms, potatoes were picked by hand on 'Tatie Picking Weeks', when local children harvested the crops, receiving a sack of vegetables in return for their labours. Trawlers from the Isle of Man or Ireland brought catches of salt cod to Workington. This was traded to the 'wet fish' shops, the fish being cut into small chunks and sold cheaply as 'coarse sprats'; these, boiled and served with potatoes, provided a cheap and nourishing meal. (Curiously, in the days of sailing ships, this was a traditional Irish dish.) And, of course, fish and chips were always the cheapest and the most convenient of all meals. In the early twentieth century, Workington had sixteen chippies or, to be more correct 'fried fish and chipped potato dealers'. In those days, a fish and a portion of chips only cost 2*d*! By the time of the Second World War, the number of fish shops had risen to approximately forty-four. The Quay just had the one at 37 Stanley Street.

With sailors of all nations coming to Workington, there was always the problem of foreign diseases — cholera, typhoid and such — so the local board erected a Fever Hospital on Merchants Quay (just a large shed, with very basic facilities, to hold suspect cases). It was very little used, so, curiously enough, the landlord of the Queen's Head Inn on the quayside acquired it and turned it into dog kennels.

Standing on the shore hills just south of the harbour was a curious beehive-shaped stone construction. This was the famous Billy Bumbly House. Painted white, it was built in the eighteenth century as a coastal marker. Its name comes from its shape and the local name for the humble bee or, as we know it better, bumble bee (that insect that the aeronautical experts say is so curiously designed that its flight is an impossibility — but don't tell the bee that!).

The families on the Marsh and Quay were a mix of locals. In addition to workers whose family roots came from northern England and Scotland, there were both Catholic and Protestant Irish. Given their hereditary differences, there were sometimes minor arguments, starting with a slanging match in the pub and ending with fisticuffs on the shore. A black eye or two later and everyone was friends again! Despite the mix of religions, there were never any problems, and, in fact, a number of local families were a mix of both religions. The 'True Blues', the local Orange Lodge who loved to parade through Catholic areas, were tolerated with good humour. When an Orange Lodge Parade was in progress around the Quay, Annie Higgins, the local midwife, would go indoors and clatter and bang on tins so as not to hear the provocative music the band was playing (such tunes as 'Come Out if You Dare', 'The Battle of the Boyne' and, a parody, 'To Hell With the Pope').

The marsh was separated from the quay by the railway station, and there was that curious phenomena of snobbery, especially by the womenfolk. The people on the Quay

liked to think that they were better than those on the Marsh, whilst those on the Marsh thought that they were better than those on the Quay. (Indeed, this seems to be a strange quirk of human nature that nobody understands!) But the Marsh and Quay were both effectively working class communities, and during bleak periods, their differences disappeared. In fact, the annual Workington Carnival — the best of its kind on the west coast — resulted from the voluntary efforts of the inhabitants of the Marsh and Quay.

The children always found their pleasures on either the shore or the countryside of the Millfields. At holiday times, their working parents sent them off with a picnic 'pack' of jam butties and Spanish water. The latter was a curious concoction made from sticks of liquorice, which was chopped up and, by vigorous shaking, dissolved in a bottle of water. Any bottle was used, including pop bottles and even oblong medicine bottles. A mucky brown, almost black liquid was the result. It was very sweet and made a nice cooling drink in summer weather. (Remember it?)

The youngsters made their own entertainment. On the shore, teenagers formed groups of Pierrots to entertain onlookers and collect for charity. In the early 1900s, they collected for the 'Clog and Clothing Fund' for less fortunate children or for the hospital, and during the First World War, they collected for the troops in the trenches. The music was generally provided by home-made instruments or, if they were lucky, a musical Christmas present.

From the 1920s and '30s the children's shows were joined by an adult concert party, who also entertained at various indoor venues during the winter. These were the 'Jovial Grousers', made up of the Morley family, and Henry Morley, an accomplished ventriloquist, was also a studio photographer who had premises on Fisher Street.

The inns around the Quay were the Coastguard, the Ship Inn, the Ship Launch, the Anchor, the Hope and Anchor, the Steam Packet, George the IV, the Queen's Head and the Wheatsheaf on Laurence Street. Curiously befitting a harbour, these pubs and taverns opened at nine o'clock in the morning. If there was a sing-song as the evening's entertainment, then it was difficult to empty the pub come chucking-out time. Mind you, the local law did not enforce the licensing hours with any degree of strictness. If you wanted a policeman after closing hours, you tried one of the local pubs! One certain innkeeper had to pass around a jug of beer before the drinkers would agree to vacate the pub. (The curiously named One For the Road).

When the recession of the 1970s came, with the partial closure of the steelworks and a reduction in the dock's trade, the local planners decided to regenerate the area with the idea of creating a modern housing estate. The inhabitants of the district were rehoused in the new estates of Moorclose and Salterbeck.

Renovated and landscaped, Workington Marsh and Quay is today a very pleasant harbourside area, but of this former, thriving maritime industrial community all that is left are curious memories and stories.

One story often quoted is that of McIver, who entered the pub with a big black eye. 'Lived in a lodging house on Church Street didn't he?: Fella called Alf Musket calls out to him, "Whets' tha been doing Wi the eye?" — "Dicker Rae hit us with the sideboard". "Well" says Alf, "He hasn't, got a side board": "Well he must have borrowed one for the occasion then!"'

Workington laundry c. 1918.

Chapter 16

Around the Town

Over the years, Workington has seen many events and local characters come and go. Scrolling through the old newspapers, one can come across reports that are 'funny ha-ha', 'funny peculiar' or 'funny yeugh', and odd events and characters that have played their roles in the story of this town. The story behind the murder of John West of Seaton, Workington, in 1964, was, to say the least, a particularly bizarre one.

A Curious Case of Murder

Capital punishment ended in August 1964 with the execution of Peter Anthony Allen and his lodger Gwynne Owen Evans (a fitting punishment, perhaps, for a very nasty case of murder in Workington). Their victim was John West, a fifty-three-year-old van driver for the Lakeland Laundry in Workington.

Peter and Gwynne were described at the time as unemployed dairymen from Preston. Gwynne Evans was not his real name, for he was born in Maryport as John Robson Walby. Under the name of Evans, he was known to the police as a thief and an inveterate liar. At one time he had been friendly with John West, but at the time of the incident, he was lodging with Peter Anthony Allen and his wife Mary in Preston. The two of them were up to their ears in debt: Allen could not pay the rent and Evans owed money on his police fines for previous crimes. Evans decided that they would go to Workington to try and borrow from his former friend, John West, who he declared was 'an easy touch' and always kept an amount of loose money.

On 6 April 1964, they stole a car from Preston to drive to Seaton, Workington, arriving there about 2.30 a.m., Allen taking his wife and children along for the 'ride'! West was at home and, despite the hour, invited them in. When the purpose of the visit was revealed, West refused Evans a loan, whereupon the pair panicked and beat West to death with a metal bar and a poker. West was also stabbed with a kitchen knife that Evans had taken from the house at Preston. The noise of the fight aroused the next-door neighbour, who came downstairs in time to see the killers speeding away. It did not take long for the police to arrest them, because they had left so many clues behind them that their escape was something of a farce.

Evans had left behind his mackintosh with his girlfriend's address in his pocket, and, to cover his bloodstained clothes, Allen had taken one of West's laundry jackets. They ran out of petrol at Windermere and stopped to inquire for a garage to fill up the tank.

Workington Free Library and Carnegie Theatre, 'The Flea Pit'.

The person they asked was another laundryman who, recognising the jacket covering the bloodstains, reported his suspicions to the police, as did the garage hand, who had seen the bloodstained shirt whilst serving them. All that they had managed to steal from West were two Trustee Savings Bank passbooks (there was loose cash in the airing cupboard at Seaton but they had missed it).

Being short of cash, they called in at the post office in Kendal where Mrs Allen, after signing the usual forms, took out her family allowance for her two children. Alfred Routledge, manager of the Workington Savings Bank, got a surprise when, two days after the murder, he received, from the Liverpool branch, withdrawal forms in the name of West. Two Liverpool detectives went to the Brunswick Street branch, to learn that a young man and woman had drawn out two sums of £5 (which was the most you could draw out on demand in those days).

Events then became even more bizarre. Imagine the bus from Preston to Ormskirk with this odd group of persons on board: two young men, both under twenty-five years of age, and both without either jacket or shirt and a young woman, with two infants, carrying a 'lamb'! After returning the stolen car to Preston, Mrs Allen and Evans had then returned to Liverpool in order to cash the bankbooks. Whilst in Preston, Mrs Allen

had notified the RSPCA, saying that they had been for a drive and found the lamb on the moors between Liverpool and Clitheroe. This weird tale aroused the suspicion of the RSPCA inspector who, on hearing of the murder, alerted the police. The pair was arrested.

Interviewed separately, the two blamed each other, but Evans had in his possession the documents from the stolen car (which the police had recovered), the victim's watch and blood on his clothes. Furthermore — wait for it — Mrs Allen had, at her interview, in her basket, her husband's bloodstained jacket. She also directed the police to where they had thrown away, in Windermere, the bloodstained knife and gloves belonging to Evans. They were found guilty, of course, and subsequently hanged.

In 1964, parliament was arguing for the abolition of capital punishment, which came about within months after the two were hanged. Curious events indeed: a Workington local was murdered on the Tuesday morning and a lamb was 'found' on the Tuesday afternoon, which led to the execution of the last two men ever to be hanged for murder.

Puzzling Problems for the Police

In 1900, the *West Cumberland Times* reported the following:

> A married woman named Mary Anson (56), who being on tour in the Lake District, has no fixed address, and had the misfortune to misjudge her carrying capacity on Friday.
>
> The alcoholic fumes got into her head. Gallant Constable Tremble came to her aid in Peter Street, and wheeled her to the hotel in Nook Street. The only vehicle at his disposal was a Wheel Barrow.
>
> Possibly grieved to think of her undignified entry there, the old lady in the cell eased her o'er flowing heart by singing patriotic songs. Failing to elicit an encore from the unmusical police, she threw her Boot through the cell window and was just commencing on another pane when P.C. Barron interfered.
>
> She was brought before Messrs H. Bowes and P. Iredale on Saturday Morning and committed to Carlisle gaol for one month.

Who is the more curious character here, the unfortunate Mary Anson or the reporter who has recorded her predicament in such a nice way? The hotel in Nook Street was, of course, the police station.

* * * * * * * * * *

The following curious offences have been extracted from the records of Gladstone Street police station during the years 1890-1923. Sergeant 'Paddy Whangs' would most probably have been in attendance.

- Absconding from school
- Arrears of maintenance order, disobeying maintenance order
- Attempting to commit suicide

Begging and sleeping out
Breaking a window
Jailed or fined for non payment of School Fees
Desertion from the Army
Deserting or neglecting to maintain your wife and family
Drunk and incapable
Indecently exposing herself to the public
Loitering and importuning passengers for the purpose of prostitution on Hagg Hill
Playing a game of chance or playing Pontoon on the Cloffocks
Stealing 1 cwt of Coke from the Workington Corporation Gas Works, value 1.3*d*
Stealing 1 cwt coal, value 1*s*, from Lonsdale Dock

All of the above were punishable by fines or imprisonment. Some even more curious offences recorded are listed below.

Drunk in charge of a horse and cart
Drunk and 'wilful' damage to a night commode in the cell and wilfully and maliciously damaging a commode [a commode is a chamber pot and also the small sideboard or stool that contains the pot]. Wilful damage to a chamber pot or Gusunder [bed].

At the Flea Pit

The Carnegie Library and Lecture Hall was opened on Thursday 6 October 1904, having been built under a grant from the Andrew Carnegie Trust. The lecture hall, which became, and still is, a theatre, was transformed into a picture house in the early days of cinema. Workington's oldest cinema, it soon gained a reputation for being a 'flea pit'.

In those primitive days of the cinema and the showing of black and white films, breakdowns in the performance were regular events. The resultant stoppages being accompanied by catcalls and shouts of 'put a penny in the gas', etc.

Things were not that much better during the late 1930s and early '40s, thanks to the projectionist of the time. Very much a local character, it was his routine to set up the projectors for a show, and then he would nip across the street to the Apple Tree for a pint or three. As you can imagine, whenever the film broke down, the shouts included 'will somebody go and get him?' Despite this practice of leaving his job for a drink, and being continually taken to task for it, the chap never got the sack! Curious, don't you think?

Beware of Bullets

In 1935, the Hippodrome Cinema on the Market Place of Hagg Hill added a ballroom to its entertainment amenities. However, this was added under the cinema! Whilst it became one of the top ballrooms in Workington, it had a rather curious problem that was never solved. Saturday-night cinema performances were often interrupted by the sound of music from the ballroom below; thus, car chases and gunfights shown to a background of the latest dance tunes!

One certain evening in 1940, a woman was shot in the leg whilst watching a western film (a curious but a true incident!) During the war, the local Home Guard had taken over the Hippodrome Ballroom as an occasional rifle range, and on this particular evening, a stray bullet had come up through the floor to hit the poor woman in the ankle.

Testing the Water

During and before the mid-twentieth century, most working class houses had no bathrooms and Friday bath-night meant a zinc tub in front of the fire, with more than one person sharing the water at times (the last one in always had to put up with not-so-clean and not-so-warm water).

In Workington, the case for a public baths had been argued since 1883, and the long-awaited swimming baths were opened in November 1934 by Tom Cape, the then M.P. The Artillery Riding School, sited to the rear of the Conservative Club on Central Square, was acquired and local firms, such as Gilmore's, Chambers, and the Lovell Bros, worked on the scheme. Previous to the erection of Workington Public Baths, most children had bathed and swum on the various shores — Salterbeck, Harrington and Flimby — and in the River Derwent. This could be dangerous, and a drowning accident that took place in the river finally prompted the town council to act.

The public baths had a heated pool with underwater lighting and a modern filtration system that dealt with 21,800 gallons per hour. The building also contained a number of slipper baths.

The Workington surveyor was more than happy with the quality of the water. It is said that, in order to get a comparison, whilst he was holidaying in Scotland, he visited a number of baths there and actually 'drank the water in which the people were bathing'! (Consider that it was not unusual for children to widdle whilst bathing —Ugh! That is what I call being a dedicated surveyor!)

Shopping Weeks

Sales are the modern way to clear the shelves of shops, but back in the 1920s and '30s, Workington Chamber of Trade and Commerce had their own ideas about retailing. Known as Shopping Weeks, triannual publicity events were held. This was when the shops promoted their goods by fancy window displays, competitions, etc. ending in a gala and a procession at the end of the week, with decorated vehicles and floats, both motorised and horse drawn. Some of these were not without their mishaps and oddities.

1928 is the year quoted when a horse pulling a railway delivery cart to the Central Station to be decorated, coming down the very steep incline of Mason Street, bolted, throwing its driver off the cart. It galloped through the junction with Harrington Road and went head first through the plate-glass window of C. E. Holmes, a chemist's shop. Whilst the window was shattered, the horse was apparently unhurt (nothing was ever said about the condition of the poor driver!).

Cumberland's first Flying Flea — the flea that never flew — was a regular exhibit in Workington's Shopping Week processions. In the early 1930s, a Frenchman invented a flying car. Known as the Flying Flea, it was basically a 'mini' with wings and a propeller.

It was never a fly-away success and was constantly breaking down. Myers & Bowman's, motor engineers of Distington, bought one but had no success in getting it to fly. Carried on the back of a lorry, it was just used for carnivals and exhibitions. It was last seen on display in Millom Museum.

The Ups and Downs of Education

Workington's Secondary and Technical School was opened in Park Lane on 17 September 1912 to replace Guard Street Technical School (which had started life in the nineteenth century as a girls' school, teaching the domestic sciences and the like). The establishment contained a secondary school for boys and girls, a technical school and a technical institute, providing day, afternoon and evening classes. Eventually recognised by the education authorities, the grammer school came into being.

Modernised and enlarged in the 1970s, it became the West Cumbria College. Thanks to curious modern ideas, this establishment became the Lakes College at Lillyhall, with the old college being demolished to make way for a smaller hospital. The original Workington Infirmary of 1884 eventually held 132 beds; this new hospital, on the site of the college, has just six beds. (Note the curiosities of progress.)

At the Dentist's

'What time is it when you go to the dentist's?' 'Tooth Hurty', was the reply. So runs a very old, corny joke from my school days.

In 1912, one of Workington's dentists was a Mr Thexton Smith, who 'invited all who are interested in the care of their teeth to call at his premises at 18 Nook Street Workington', and he further advertised himself with little verses, such as:

> Even so small a thing as a tooth has caused:
> Generals to lose battles, Ministers to lose the threads of their discourse,
> Philosophers to cease philosophising and Poets to write drivel instead of Elegiacs.

You do not find dentists advertising like that these days!

Has There Been Progress in Public Services?

Was Workington a clean town? Despite the steelworks and other industries pouring out their share of sooty smoke, it would seem to have been so! At least, according to the *Whitehaven News* of 11 January 1934 — or was this particular, and rather curious, article being a bit cheeky?

> Workington's Dust Chariots
>
> In other directions also the Workington Corporation is forging ahead. A short time ago it was one of the most primitively scavenged towns in the county.

The Dustman revelled among the tradesmen's refuse as Biffin revelled in his dust heap. Today all that has changed and anywhere we may go in Workington we have to dodge not only the Butcher boy's Motor Van but the Corporation Dustcart signalling its fiery oncoming with as musical a sound as ever was emitted by a Rolls Royce Horn. The Workington Dustman rejoices in his cleanliness. He might if so disposed wear his summer flannels at his work and emerge speckless at the end of his working day. But other good things are in store for him.

It is proposed that he who presides over a hand cart shall be motored to the remote places in which he begins his day's toil, the idea being that he will swiftly deal with the contents of buckets that, standing long in the streets are so often crushed by cars that police insist on being driven to hug the kerb.

Truly things are moving in Workington.

A Day Out with the Kebby Club

The one sport or method of relaxation very well favoured among the working classes was that of walking (not so much competitive walking races, which were occasionally held, but more the rambling variety). At a time when Workington was a busy industrial town, 'excursions' to the fresh air of the lakes became a welcome break from daily toil. By the 1920s and '30s, charabanc tours, especially those organised by the churches and Christian fellowships, were a regular part of the social scene. Factories and commercial institutions also treated their employees to 'days out'. Workington Chamber of Trade organised trips to such as Caldbeck and Silloth for the town's shop assistants. These were also the days that saw the birth of the Rambling Association and its many offshoots of hiking and cycling clubs. All clubs aimed to enjoy the delights of either the seaside or the countryside, with the emphasis on the health and well-being of youth.

Workington's earliest rambling club entitled themselves the Walking Stick Club or Kebby Club (kebby then being the dialect term for a walking stick). It consisted of about forty or so members, mainly steelworkers, an all-male organisation, to enjoy the delights of fell walking. Its secondary aim was to obtain the maximum of enjoyment by refreshment stops and ending the day with a slap-up meal at some hostelry or other.

June 1925 saw a very memorable outing. The Kebby Club first took the train from Workington to Threlkeld (east of Keswick on the Cockermouth to Penrith railway). From here they set off to walk through St John's Vale to the Queen's Head at Thirlspot (Thirlmere). They then refreshed themselves with a few beers, after which they paid a visit to the new Thirlmere Dam and its water works. Next, they climbed Armboth Fell. The intention was that, as a party, they would make for Watendlath in Borrowdale, but disagreements broke out and they then split up into smaller groups (and proceeded to get lost!). No doubt, the heat of the day plus the intake of ale caused them to lose all sense of direction, because nobody reached Watendlath. Some crossed the fell and down into the Derwent Valley to make a stop at the Lodore Hotel in Borrowdale, where pies and pints were thankfully consumed (they stayed there for the rest of the day!). Some arrived at various points in Borrowdale, whilst others found themselves at Castlerigg Stone Circle, having crossed the fells via Walla Crag and High Street in the opposite direction to Borrowdale altogether!

They ended the day in a glorious fashion. The Lodore Group, not wishing to walk another step (could they even if they wanted to?), obtained a waggonette drawn by a pair of fell ponies, and the Kebby Club made a return to Keswick, picking up the rest of the stragglers on the way. It is said that the local townsfolk lined the streets of Keswick to give hearty cheers as this procession, led by a wagonload of (probably inebriated) ramblers made its way up the main street of the town for a dinner at the Royal Oak Hotel. The day ended by them catching the last train to Workington. (A great day out indeed.)

Workington is Almost Destroyed!

During the Second World War, there was a curious incident, during which the centre of the town could have been entirely destroyed.

The event occurred in 1944, when a munitions train, drawing twenty wagons of shells, explosives, etc. ran away on the Buckhill/RNAD line on the incline down from Seaton. The signalman at Calva Junction, having been alerted by the continuous whistling of the runaway, had the presence of mind to divert the train away from the buffer-stopped siding and onto the main line, from where it ran towards Workington Central Station, eventually coming to a halt on unoccupied rails at Navvies Bridge. Thus, the signalman prevented what would have been a large enough explosion to have destroyed the centre of the town.

By a curious turn of fate, Harold Goodall, the driver on this loco, was the same driver who was on the ill-fated train carrying land mines that blew up Bootle Station on 24 March 1954, killing him in the process. His fireman, Norman Stubbs, was awarded the George Medal. Ironically, Harold should not have been on this train! He had exchanged shifts with Herbert White of Workington, the scheduled driver.

The first bombs fell on Workington on 27 October 1940 between the Merchant's Quay and the Oldside Iron Works. The Home Guard detachment on duty at that time, being railwaymen, fixed fog detonators to the line to alert passing traffic. One of the Home Guard men, a Private H. G. Neill, arrested a man found wandering on the line at Calva Junction. Was this mysterious man an enemy pilot? No, he turned out to be a Jehovah's Witness, and he was heavily fined for trespassing on the railway.

The Post Office

Yesterday's events and activities are today's curiosities. Workington post office originated on John Street and then moved to Finkle Street, where today these premises are a bookmakers and betting shop! In 1901, it was open weekdays from 7.00 a.m. until 9.00 p.m. for general sales (stamps, envelopes, parcels, telegrams, etc.). For money orders, savings banking, issue of licences and 'Claims for Spoiled Stamps' it was open weekdays, 8.00 a.m. to 8.00 p.m. It was open for general sales on a Sunday, 8.00 a.m. to 10.45 a.m. There were four deliveries of letters and parcels per day at 7.00 a.m.,

11.30 a.m., 3.30 p.m. and 6.30 p.m. Collections from sub-post offices, pillarboxes and wall boxes were carried out five times a day and once on Sunday.

Today's services, curiously, have changed significantly indeed.

Inside the dentist's surgery of 1912.

A most unwelcome visitor.

The Flying Flea that never flew.

Chapter 17

'Don't Go Down the Mine, Daddy — There is Plenty of Coal in the Cellar.'

For some Workingtonians a literal truth, because in some parts of the town, the houses and shops are built on former coal seams. With coal deposits lying underground along parts of the west coast of Cumbria, and even out to sea as far as the Isle of Man, it is only natural that this mineral would be exploited at a time when emerging industries called for its use. There have been coal mines in Workington since the seventeenth century, the coal being extracted for domestic use.

Sir Patricious Curwen, the Royalist, used coal to heat Workington Hall, and even Galloper Curwen has been reported as having pits from forty to fifty fathoms deep. By the middle of the eighteenth century, some pits in Workington had been sunk to a depth of well over 100 fathoms. In 1774, the Workington Colliery produced 23,000 tons of coal, with production climbing to 33,350 tons. Two years later saw John Christian marrying the heiress of Workington; he became known as John Christian Curwen and took over these pits. Eventually, John Christian Curwen sank another three shafts on the shoreline that became the Chapel Bank Colliery, and in total, the Curwens owned and operated ten pits in Workington itself. In the period 1790-1870, pits were sunk and the seams of coal worked out, and the companies then moved on to another site to sink yet another shaft for coal, and so on. Within the town itself, there have been no less that forty-one pits sunk at some time or other, so under the town, there must be a network of tunnels. So far, however, there are no signs of subsidence. Well, the other year, a small hole appeared on Corporation Road which could have been from Elizabeth Pit, which was sited just to the south-west of the then West Cumberland College (now the new hospital). Victoria Road School also had problems with gas seeping from underground!

It is interesting to see just where some of these pits were sited and it will no doubt be a surprise to the inhabitants who reside in these locations. John Pit, for instance, was roughly sited at the junction of John Street and Harrington Road. Back in 1800, John Christian Curwen was fined a year's production (in today's terms possibly a million pounds) because his miners, following the coal seam, had strayed and were caught robbing coal from one of Lord Lowther's pits on the northern side of the town under the Cloffocks. This actual event suggests the presence of a mine tunnel that travels for a quarter of a mile under John Street and the regenerated shopping area of Workington. Elizabeth Pit was in the area of the old college and Vulcan's Park; Church Pit stood at the junction of Hope Street and, again, Corporation Road (aptly named, because the Gospel Hall was later erected on this site); Hope Pit was, again, located at a junction, that of

1763 - the birth of Workington's Iron industry

Charcoal from southern Scotland
Iron Ore by packhorse from Frizington.

BAREPOTTS MEADOW
NEAR HOLEGILL

- A mill for slitting and rolling bar iron
- A double forge for refining and drawing bar iron
- A foundry with several small furnaces
- A boring mill for boring cannon cylinders etc
- A grinding house and turning house and many other conveniences

The birth of Workington's Steel Industry.

Vulcan's lane with Hunter Street; Lanty Pit was roughly halfway along Hartington Street, today a double row of terraced houses; and Smithy Pit was at the junction of St Michael's Road with Chilton Street (during the 1912 coal strike this was one of the locations from where locals gathered coal, which lay just under the ground here).

In most industrial towns, town planners seem to have intentionally built larger houses for traders and the professional classes on the heights that surround the town itself, far away from the smoke and grime of the factories, and this was the case with Workington. The area of Banklands and St Michael's Road may have overlooked the town from the heights as an 'upper town' but it also included the seven pits of Banklands Colliery. Bowness Pit and the 'Drift' were both to be found on Moorclose Farm, now Moorclose housing estate, and are just two of the forty-one pits in Workington that were eventually built over when the present town was created in the 1860s and 1890s.

'Don't Go Down the Mine, Daddy — There's Plenty of Coal in the Cellar.'

The Opening of the Chapel Bank Colliery

Just a short account of the rejoicing of the opening of Ladies Pit taken from *The Cumberland Paquet* newspaper of 18 and 25 November 1794.

> To celebrate an event which is considered of vast importance to the town and neighbourhood, Mr Curwen gave great entertainments on the opening of the Chapel Bank Colliery. On Friday, the Sisterly Society of which Mrs Curwen is Lady Patroness went in procession to the pit. These were followed by the miners dressed in 'White Flannel Suits',- the Honourable Society; The Friendly Society; the Seamen, nine other carriages; several post chaises also attended. Two Marquees were pitched and wine and cake were provided to all who attended. Several barrels of ale were broached and given to the populace. The procession then moved to the pit which was named Ladies Pit, in the presence of thousands who rent the air with three times three HUZZAS. A wagon of coals was filled and drawn by miners (still in their White Flannel Suits?) to the shipping. The coals were put onboard the 'Thompson', Captain Henry Tiffin. - The bells were rung, guns fired, the ships were clothed with colours and flags supplied by Mr Curwen were displayed by the societies. All the workmen, seamen etc had dinners provided at different public houses. At night there was a general illumination and a ball at the Assembly Rooms and a supper at the hall for 150 persons. Mr Curwen was very liberal. Seventy-five ladies and gentlemen from other parts of the country dined at Workington Hall on the 14th inst. And on the next day upwards of one hundred persons, chiefly of the inhabitants of Maryport and its vicinity dined at Ewanrigg Hall. Mr Curwen made a present of £50 to the seamen for the purpose of forming a Friendly Society of Mariners; - and he subscribed 5 Guineas per Annum for the support of the Sunday Schools of Maryport.

The First Health Service

As you can see, John Christian Curwen was a great benefactor to industrial Workington. For his miners he created a Colliers Society, a compulsory contributory Sickness Benefit Scheme. Ring a bell? It was a forerunner of the Health and Insurance Act, which is otherwise known today as the National Health Service.

He also improved the working conditions of the miners by taking certain safety measures. Under his Colliers Scheme, members received sickness benefit of 15s 6d per week which then dropped to 8s per week after the first twelve weeks. (An average adult wage would have been about 16s per week.) Married women received 1g on the birth of a child, and the widow of an employee received £2 a year for each child under ten years old. If a fatal accident occurred then the widow received the sum of £10 to help towards the funeral expenses (this cost was met by a levy of 6d per worker). John Christian Curwen, as employer, paid into this scheme an extra thirty per cent of whatever was collected via the compulsory contributions of 3d, 5d or 6d per week (these sums were dependant on the miner's weekly earnings) and from his own pockets he made up any shortfall payments. He also paid the salaries of 2g each to provide doctors for his workforce. All of his nine pits came under this benefit scheme. He was the first mine owner in the north of England to introduce steam-driven pumps into the mines.

These pumped out the water and circulated a stream of fresh air to lessen dangers from inflammable gases. When he sank the Isobella Pit in 1807, to a depth of 300 yards, he met with flooding problems. Not surprising, for this pit sited to the south of John Pier was under the sea! The installation of a 160-horse-power steam engine soon remedied that situation. Despite the hazardous conditions of winning coal from underground, between the years of 1757 and 1815, only twenty-nine Workington miners lost their lives in mining accidents; records for the early Workington Collieries do not indicate any occasion when fire, damp or gas was the cause of an accident.

Workington's only pit disaster was, curiously, the fault of one man. Where a mine tunnel was driven under the sea, the roof was supported on pillars of coal, measuring fifteen yards by ten yards, as a further safety measure. A Ralph Coxon from Newcastle was the manager of the Chapel Bank Colliery and, in an effort to gain more coal, he instructed the mine overseers to 'rob' these pillars and reduce them to eight yards by seven yards. As a result, there were a number of roof falls at Isobella Pit and, in November 1836, four men were drowned. Protests to Coxon were ignored and, despite miners leaving the pits and their replacements having to be paid more money, Coxon was able to convince his employer, Henry Curwen, son of John Christian Curwen, that everything was perfectly safe.

Then, on the night of 30 July 1837, the sea broke through into the main band of Lady Pit. It made a hole of about eighty yards in width and at fifty yards below the low water mark and flooded all three pits. Thirty miners managed to escape through a drift mine at Union Pit near to the Chapel Bank Cottages, but twenty-seven miners and twenty-eight horses were lost. (Their remains are still there under the sea.) It could have been worse, but the annual circus was in town at the time and a number of miners who should have been on that shift had taken time off to take their families to the circus.

Ralph Coxon was immediately blamed and an angry crowd, armed with sticks and pistols, hunted him with murder in mind. They never found him! Rumours had it that he had been hidden by some of his friends, who helped him escape from Workington and justice.

This enforced closure of the Chapel Bank Colliery was a severe blow to the town's industry. By 1860, only Jane Pit (a later addition to the Curwen Colliery) was working, and in 1893, the Curwen collieries finally ceased production.

* * * * * * * * *

As you approach Workington on the A597, just beyond Moss Bay on the left-hand side of the road, you will see what appears to be a small, turreted, castle-like ruin. These are the remains of Jane Pit, a listed ruin and the last of the Curwen pits. Why is it castle-like? Apparently John Christian Curwen was fond of this style of architecture. When he altered Workington Hall in the 1780s and 1790s, he kept its original castle-like appearance, and his estate farm, Schoose Farm, was also built to resemble a castle.

A Case of Wind and Water?

A rather curious story refers to the Harrington Colliery, which overlooked the sea just south of the village of Harrington.

'Don't Go Down the Mine, Daddy — There's Plenty of Coal in the Cellar.'

After the closure of the first of the pits, the locals began to hear weird sounds coming from the pit shaft itself. Moans, groans and, at times, squealing or whining noises were heard, disturbing the sleep of those who lived in the vicinity. Some people said it was a ghost; others said that a dog had been trapped down the pit. Interestingly, the Scottish Presbyterians said that the 'Devil had got the Pope down there and was tormenting him'.

Eventually, they called in some mining experts to investigate the noises; the experts, after much deliberation, and without actually going down the shaft, declared that a current of air was blowing across a small fall of rainwater and creating the sounds. The noise was eventually blocked out by filling in the head of the shaft, but was it a ghost, was it a trapped animal or was it just a case of wind and water?

A map showing the many pits in the town of Workington.

The twelfth-century Curwen Coat of Arms.

Chapter 18

Tales in the Toilets

To discover the history of Workington, the best and logical place to go to is, naturally, the Helena Thompson Museum, Park End Road, but there is also a secondary, and very curious, source of information.

During the recent regeneration of the shopping centre, new public toilets have been erected. Not only do these toilets display a small aquarium in the entrance hall but also, upon the tiled walls, can be seen snippets from the town's history.

LOCAL HISTORY TO BE FOUND ON THE WALLS OF THE PUBLIC TOILETS;

NOW *THAT IS* CURIOUS WORKINGTON!

Local history in the toilets.

> In a time when there was nothing here but trees, did a Saxon called
>
> # WEORC
>
> settle in this place and give it a name?
> • Weorc-ing-tun •
> Etymologists differ, and no-one knows for sure...

The saxon who started it all.

> # The Bessemer
> # 26 July 1974
>
> # THE LAST BLOW
>
> The carbon flame of the last blow lit up a sea of sad, thoughtful faces
>
> Many tears were shed this day

Closure of the blast furnaces.

> ICE CREAM Made By Machinery
> Sold From Handcarts
>
> # HOKEY POKEY MAN
>
> H TOGNARELLI
> BRIDGE St & POW St
> WORKINGTON

The Italian ice cream experts.

> By 1888, blast-furnace workers toiled for 84 hours a week. A Workington Irishman by the name of
>
> # PATRICK WALLS
>
> led the fight for an 8-hour daily shift.
> A founder member of the trades union movement, he went on to become the town's first Labour mayor.
> He was said to be:
> cultured, god-fearing, unbribable; pioneering, tolerant, helpful; a fighter for the rights of man

Paddy Walls. A fighter for the rights of workmen.

Acknowledgements and Sources

K. Jamie, *On the Waterfront*, Carnegie Arts Centre, 1993.

Various Issues of the *Evening News & Star*, Frank Carruthers.

The West Cumberland Times & Star, Whiteoak (dates, where known, to be found in the text).

Ian Ferguson for use of his historical files.

D. Woodruff, *Workington in Old Picture Postcards*, Vols 1 and 2, European Library Publications, 1987 and 1990.

With special thanks to Pat Martin, Helen, Ivison, Sheila Richardson and all those other 'collaborators' from the Workington & District Civic Trust and the Helena Thompson Museum.

For the artwork in the toilets, thanks must go to Paul Scott, Thomas Bewick, William Yarrell and Robert Drake (text).

Photographic Index

1. Workington Hall today
2. Camerton Church
3. St Michael's Parish Church
4. Helena Thompson Museum
5. The quay side at Workington
6. Workington Hall after 1790
7. Workington Brewery
8. The Luck of Workington

Chapter 1
9. A recent trip to the Mary Queen of Scots memorial
10. Portrait of Mary Queen of Scots
11. Memorial to Mary Queen of Scots' arrival

Chapter 2
12. A number 48 bus

Chapter 3
13. The unique bus station in 1926

Chapter 4
14. The television set of 1932

Chapter 5
15. The Nags Head. Workington's oldest pub

Chapter 6
16. An Uppies and Downies player of the early twentieth-century on Curly Hill
17. Uppies and Downies played on a flooded Cloffocks
18. The Uppies and Downies ball of 1887

Chapter 7
19. Darky Joe from Chicago, c. 1905
20. Boots used on the Marathon?

21. A cyclist from Harrington – did he follow the walkers?

Chapter 8
22. Beecham's Pills: the cure all
23. The yachts at Bownes Marina

Chapter 9
24. Workington hospital

Chapter 10
25. The motorised fire engine

Chapter 11
26. Was Galloping Harry dragged to his death down these stairs?

Chapter 12
27. Murder at the Friars Well

Chapter 13
28. The Butter Market on the Market Square in the nineteenth century

Chapter 14
29. The Lowther Arms Inn on Portland Street
30. Portland Square showing the monument to Dr Peat

Chapter 15
31. Workington main station divided the marsh from the quay

Chapter 16
32. Workington laundry *c.* 1918
33. Workington Free Library and Carnegie Theatre, 'The Flea Pit'
34. Inside the dentist's surgery of 1912
35. A most unwelcome visitor
36. The Flying Flea that never flew

Chapter 17
37. The birth or Workington's Steel Industry
38. A map showing the many pits in the town of Workington

Chapter 18
39. The twelfth-century Curwen coat of Arms
40. Local history in the toilets
41. The Saxon who started it all
42. Closure of the blast furnaces
43. The Italian ice cream experts
44. Paddy Walls. A fighter for the rights of workmen